A YEAR ON A DAIRY FARM

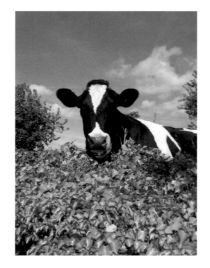

Richard Cornock

First published 2010, reprinted 2011. This edition published 2015

Amberley Publishing
The Hill, Stroud
Gloucestershire, GL5 4EP

www.amberley-books.com

Copyright © Richard Cornock, 2010, 2015

The right of Richard Cornock to be identified as the Author of this work has been asserted in accordance with the Copyrights, Designs and Patents Act 1988.

ISBN 978 1 4456 4846 0

British Library Cataloguing in Publication Data.
A catalogue record for this book is available from the British Library.

Typeset in 10pt on 13pt Sabon.

Typesetting by Amberley Publishing.
Printed in the UK.

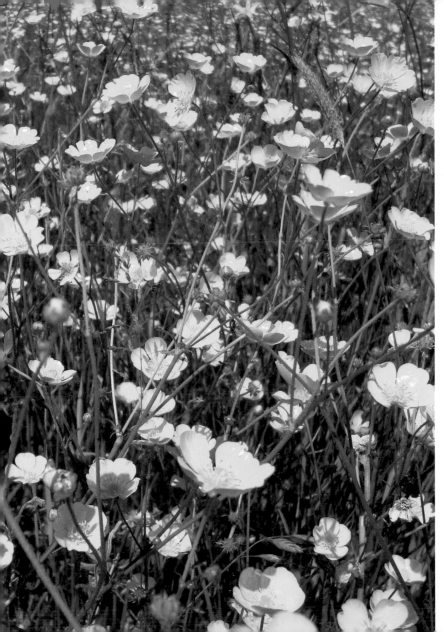

CONTENTS

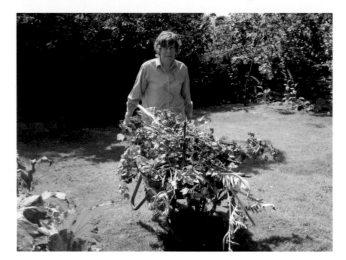

Janice Cornock

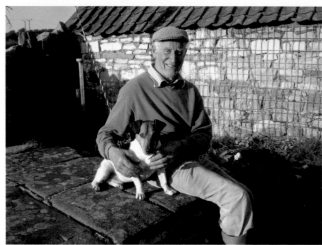

Bill Cornock

Rusty

Tom and Rich Cornock

PREFACE

For those of you who are wondering how a farmer ends up with a book on a shelf in a bookshop, the answer has to be 'quite by accident and with a little bit of luck'. At the start of this project I didn't intend to produce a book, just a record of what happens on our farm during a typical year. Using a pocket digital camera costing less than £100, I proceeded to snap everyday scenes around the farm from January till December, and then had the idea of getting the pictures privately printed in a one-off book as a Christmas present for my parents. Several people who saw this book suggested I should try to get it published and after a little internet research I approached Amberley Publishing, a local firm, and found myself on the road to authorship. This book is the result of some guidance and coaxing from the Amberley team, and truly reflects what it's like to live and work on a small family dairy farm in Gloucestershire. None of the photos are staged and the text included with the pictures comes from the heart, rather than from a trained writer. Hopefully this book will give an insight into the day-to-day running of a small dairy farm, and give people something to think about as they drive past fields of cows on their way to work, or enjoy a pint of fresh milk on their cornflakes in the morning.

ACKNOWLEDGEMENTS

Thanks go to my wife Sam for her help and encouragement with the text of this book; all the Cornock family for their continued commitment in running New House Farm; everybody at Amberley Publishing for 'giving me a chance'; The Beatles … well done lads I think you've passed the audition; the Thursday night boys for the finest wit and banter this side of the Severn; and finally all those who have dedicated their lives to making this country a more green and pleasant land.

A percentage of the author's royalties from this book will be donated to the Royal Agricultural Benevolent Institute, a grant-making charity that supports members of the farming community facing need, hardship or distress.

Rich Cornock

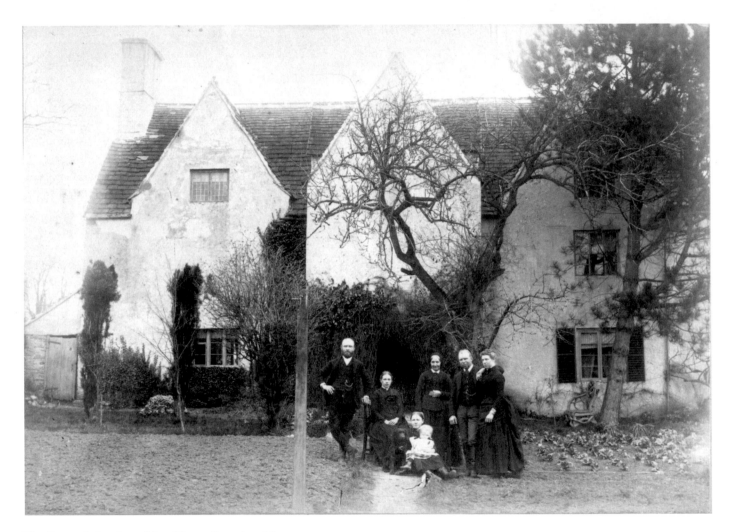

The Cornock family at New House Farm in 1887.

INTRODUCTION

Situated in the west of England, Gloucestershire is an ancient county consisting of part of the Cotswold Hills, the Severn Valley, and the entire Forest of Dean. The county has a wide range of agricultural activities which have evolved over the centuries, with the Cotswolds being largely arable, the Severn Vale renowned for dairy, and the Forest of Dean for sheep.

New House Farm in the village of Tytherington is a typical small family farm similar to many that are dotted around the Severn Valley. The land in the Severn Valley has been farmed for thousands of years and evidence of early occupation can be found throughout the farm; when certain fields have been ploughed, pieces of flint are sometimes found in the newly turned soil. Flint is not a local stone and these flakes are in fact evidence of Stone Age man on the site. These flints would have been used for the preparation of hides and skins for clothing or bedding, and for the working of wood, bone, or other softer materials. A flint axe and arrow head have also been found, which indicate a more sophisticated working of the stone, and could post-date the scrapers by thousands of years.

Evidence of Roman occupation of the land has also been revealed by pottery and coins from the third century AD in some of the fields. Although no sign of a Roman villa has been found on the farm, excavations have revealed Roman settlements in the vicinity. So far nothing has been found to indicate there were other settlers on the farm between the Roman occupation and the medieval period. Later occupation has been indicated by the discovery of two silver hammered coins in a ploughed field: one from the reign of Edward I (1272–1307), and the other from that of Henry VII (1485–1509).

The current farmhouse dates from the early 1600s and indicates a builder of some wealth who quite possibly had connections with the Cotswold woollen industry, which was at its peak at the time the house was constructed. During recent renovation work, teasel heads, a hand carder, and a weft sword were found in a disused smoking chamber in the house; an indication that wool was being processed at the farm. Along with wool production the farm probably also produced local cheeses such as single and double Gloucester, as well a large quantity of cider from the orchards that surrounded the farmhouse.

Although it is not known who built the farmhouse, it is possible to say that from the start of the eighteenth century the Pullen family lived at the farm. On one of the beams in the hallway are carved two Pullen initials and the date 1712. The Pullen family continued the live at New House Farm until the arrival of the Cornock family in nineteenth century.

The name Cornock has been associated with the West Country and the county of Gloucestershire for centuries, and it is possible to trace our family tree as far back as 1485. Before moving to New House Farm, the Cornocks had lived at various times in Oldbury, Iron Acton, Berkeley, and North Nibley. Various branches of the family can still be found in these areas, as well as lines that exist in Canada, Australia, and America.

The Cornocks that arrived at New House Farm were originally from Oldbury and took over the farm after marrying into the Pullen family. Since then the name Pullen has been used as a middle name in our family. James Pullen Cornock is recorded as being at the farm

in 1858, but he could have arrived before this date. At this time the farm was tenanted and owned by the village squire, but in the early 1900s my great-grandfather, William Cornock, bought the farm with a loan of £2,000. Since this time the farm has seen many changes, going from a mixed farm of arable, beef, sheep, and dairy, to a purely dairy enterprise. During this time the number of employees on the farm dropped to just family labour, with the increasing reliance on contractors to carry out many of the operations on the farm. One of the biggest changes has been the replacement of horses with tractors. To me this seems like something from a history book; however, this has only happened in my father's lifetime and evidence of the shire horses that used to work on the farm can still be seen around the buildings in the form of old bits of tack or horse shoes.

The farm is currently run by my father Bill, myself, and my brother Tom. We have a milking herd of eighty British Friesian cows and produce farm-assured milk which is sold to Dairy Crest. We also rear our own replacement milking cows and a small number of beef cattle.

We have always managed the farm in a sensitive and sustainable way, and our long family connection with New House has engendered a strong bond between us and the natural beauty of the surrounding landscape. Eleven years ago we joined the Countryside Stewardship Scheme (CSS) that was set up by Natural England to help enhance and conserve English landscapes. Since joining the scheme we have continued to manage the trees, ponds and fields in a sustainable way and have focused on a number of projects. We have laid considerable lengths of hedgerow in the local Berkeley style, pollarded trees, restored ponds, replanted hedges, converted three fields to organic hay meadows, managed a Common for wildlife and biodiversity, restored a small orchard, and planted a number of trees around the farm.

Despite the volatility in the milk industry over the last fifteen years, which has seen many dairy farms give up, we are committed to the long-term future of the farm and its surrounding landscape. Although our ten-year CSS has now finished, we are involved in another environmental scheme called Entry Level Stewardship (ELS), and have just been accepted onto the Higher Level Stewardship (HLS) scheme. This will provide us with another ten years of focused environmental management.

You can find out more about the author by visiting his website, www.richardcornock.co.uk; to watch videos of him at work on the farm, visit Richards Youtube channel, 'thefunkyfarmer'.

JANUARY

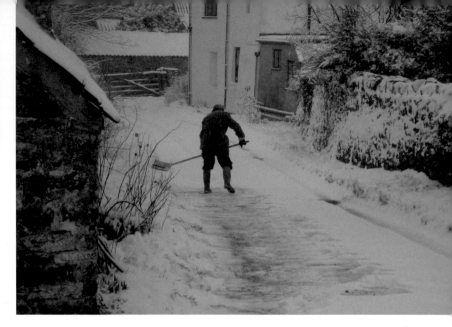

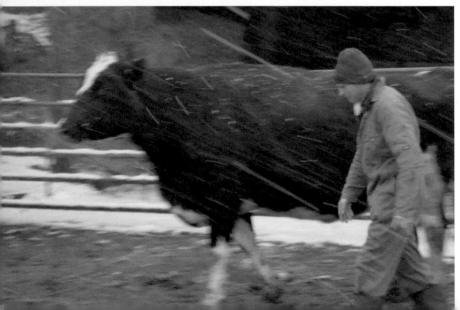

January is the obvious place to start a book entitled 'A Year on a Dairy Farm', although, in farming life, the beginning of the year is really a continuation of everything that has gone before. By January the cows have already been kept inside for several months and the routine of milking, feeding, cleaning, and bedding down has become a familiar pattern that fills most of the daylight hours, while jobs such as foot trimming, vets visits, or maintenance of machinery and buildings take up any spare hours. You could say it's just a case of putting your head down and getting on with the job until spring and longer days give you time to draw breath and take stock. While spring still seems a very long time away, there is still plenty of planning to be done in preparation for its inevitable arrival. For example, fertiliser and maize seed is ordered in this month to get a discounted price and to ensure its prompt arrival before it is needed.

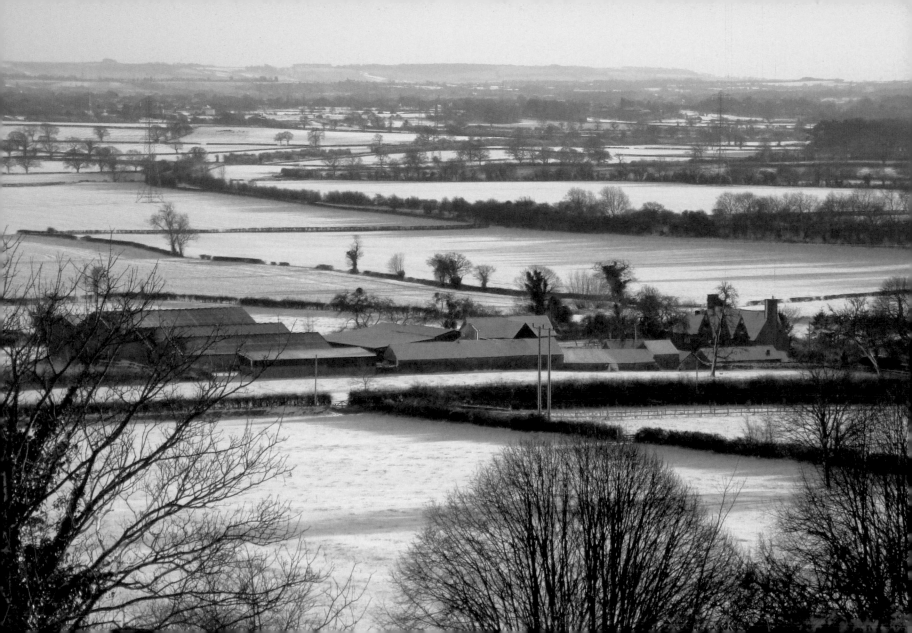

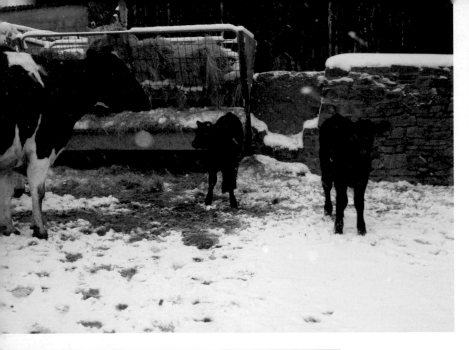

Whilst appreciating the changes in scenery that the snow brings to an otherwise drab and dreary month, it can also bring its own headaches to those working on the farm. Of primary importance is that the milk is still collected by the tanker. On our farm we have two days worth of storage in the bulk tank after which the milk must be collected; with the fall of snow this cannot always be guaranteed. This makes for a potentially anxious time as weather forecasts are checked and calls are made to the transport company office to see whether the tankers are operating and able to collect in this area. At the same time, all efforts are made to keep the driveway and farm yard clear of snow and ice in the hope that if the tanker gets on the farm it won't get stuck or career out of control on an ice patch into a building or wall. Many bags of salt and wheel barrows of grit are used to make the surface of the yard drivable. In the worst case scenario, the tanker may be unable to reach the farm and up to four milkings worth of milk will have to be pumped into the muck spreader and dumped on the land with the loss of hundreds of pounds and hours of work for nothing. Thankfully, situations like this are rare and even with several inches of snow the tanker still managed to get through to our farm.

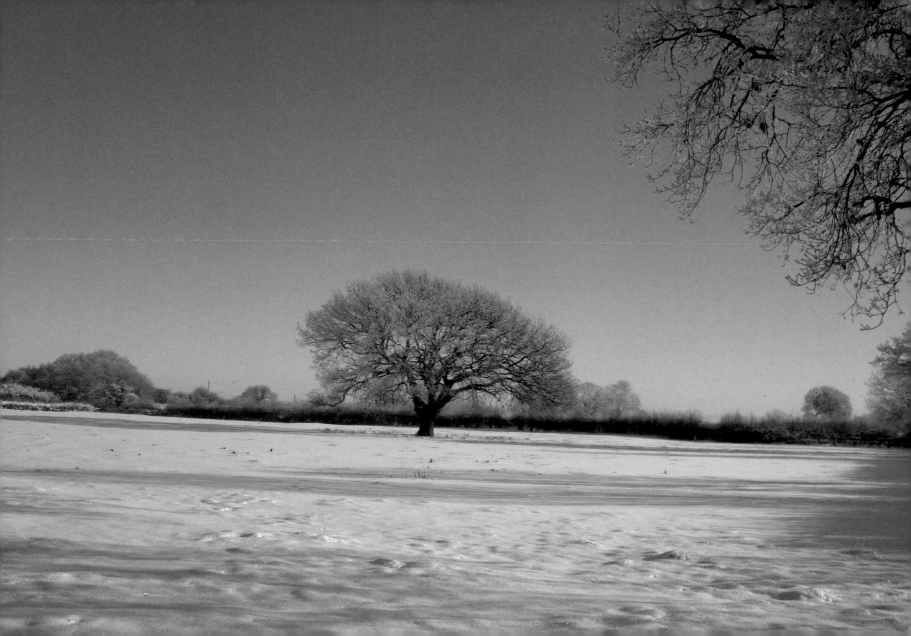

The arrival of snow brings unexpected delights and difficulties to the farming day; in some ways waking up to a proper covering of snow can make you feel like a child again and looking at the snow-covered landscape really does bring a different perspective to the day. All the regular features of the farm disappear or are transformed into scenes from a Christmas card; there really is something magical in being the first person to walk through a field of crisp fresh snow glinting in the morning sun, whilst breathing in the crisp cool air. It's also a time when you can see how alive the countryside is even during these cold dark months. Most of the time during winter the surrounding fields look empty and void of life, but a scattering of snow reveals animal footprints from a whole variety of creatures including foxes, badgers, rabbits, and deer, that somehow survive in this bleak environment. Despite these extremes of temperature, the cattle cope well with the snow; they grow a slightly longer coat of hair in the winter and are quite content in their unheated winter housing. However, their milk yield does usually drop when it gets extremely cold as they drink less water due to its freezing temperature, and they use more energy to keep themselves warm.

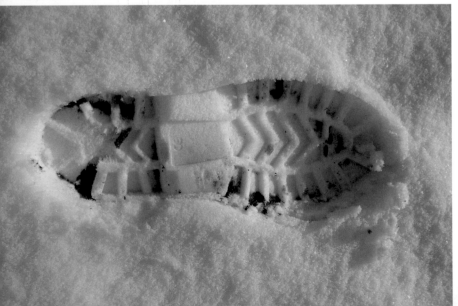

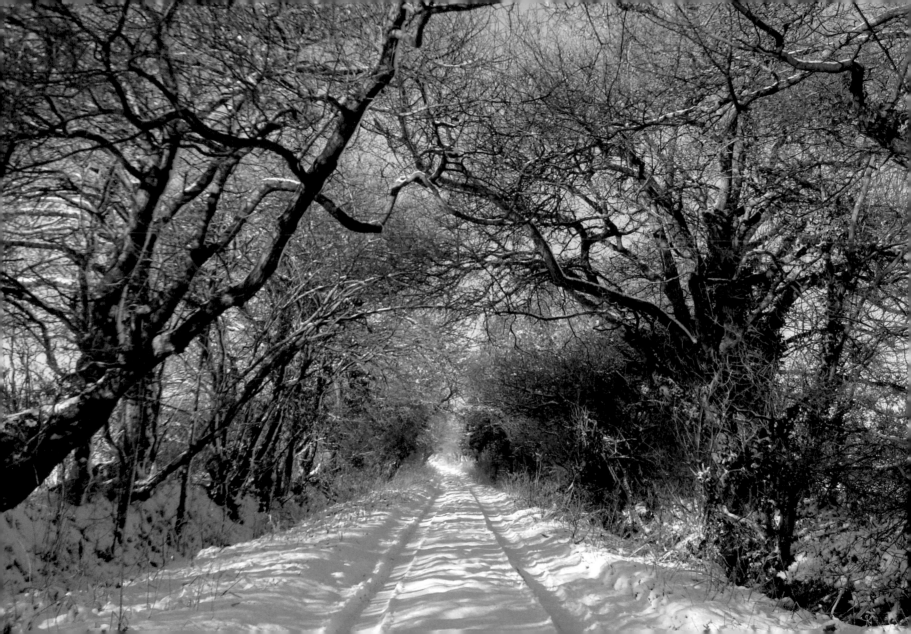

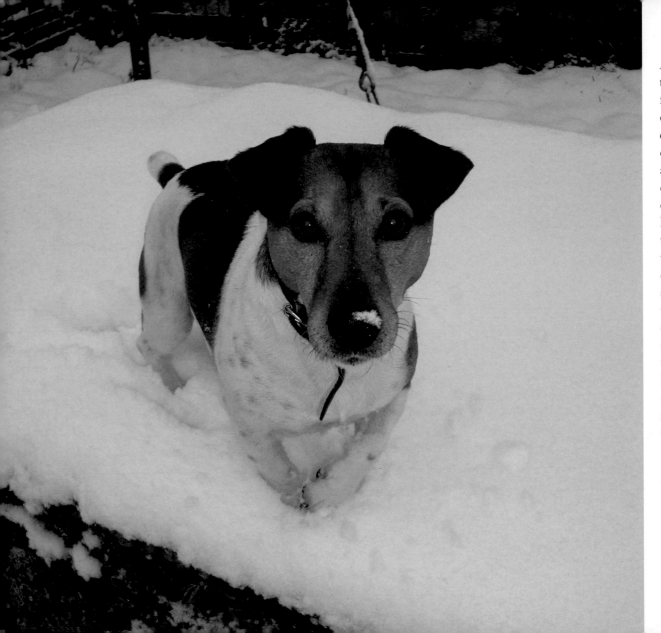

As well as a surprise for both us and the cattle, the snowfall is also a shock for the farm dog, Rusty. Coming out of his shed in the morning to a completely white landscape must be quite disorientating; after a quick sniff around it's not long before he has darted back into the house to curl up on his favourite chair in the farmhouse kitchen. Just like the dog, it doesn't take long for us to head back into the house once the morning's work is done. While damp boiler suits gently steam on the Rayburn, it's a relief to tuck into one of mother's casseroles or cottage pies before heading back outside to carry on. Despite the warmth of the kitchen, the rest of the house can be a little draughty; because of the building's age there is no double glazing or cavity wall insulation, although the thickness of the walls – 3 feet in places – must keep in some heat. At least now with central heating we can heat the whole house easily and not have to haul coal or wood into the bedrooms as they used to do, and thanks to roof felt snow no longer blows through the tiles into the attic like it did when my father was a boy.

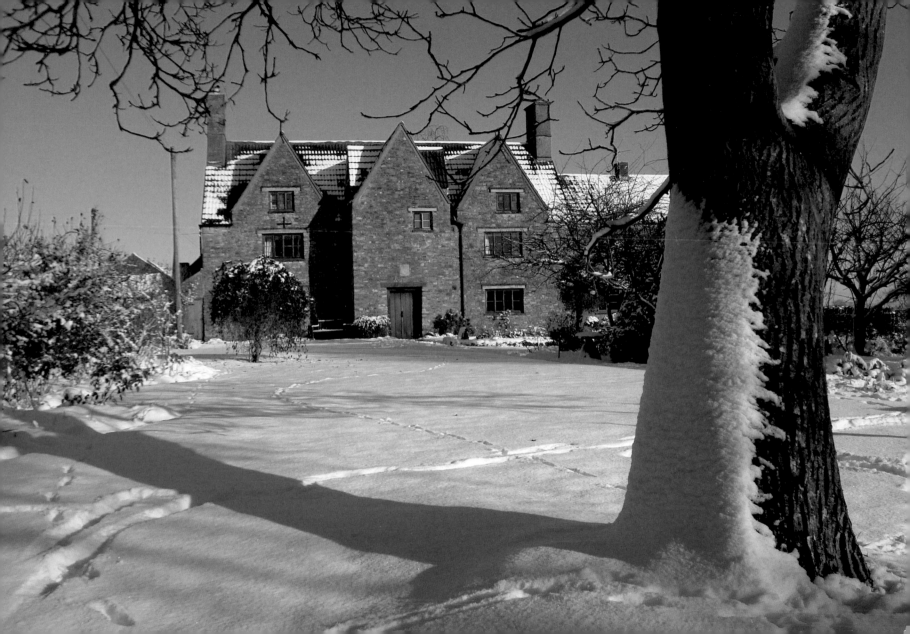

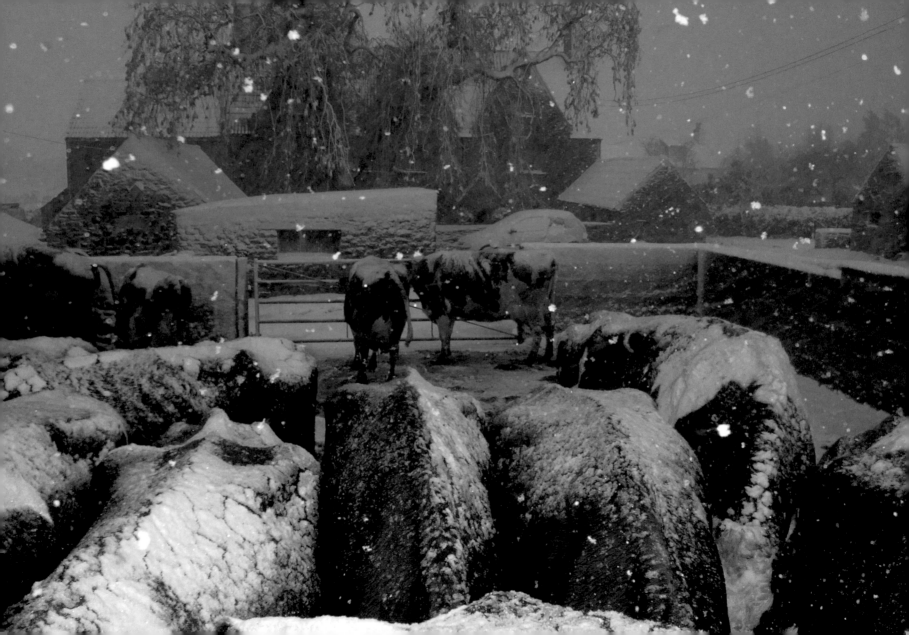

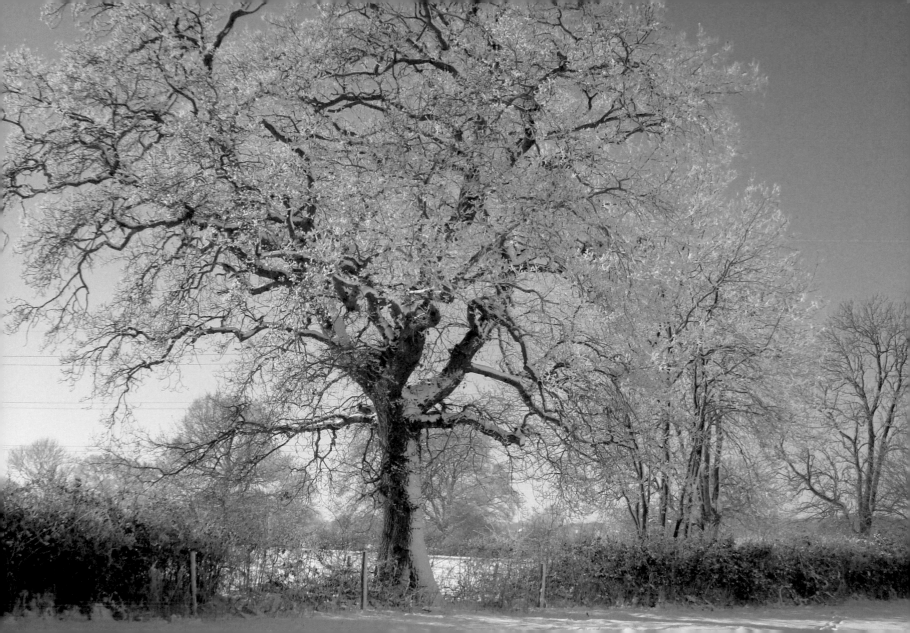

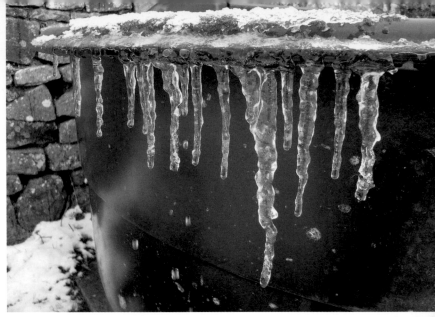

With the freezing cold temperatures that January nights can bring, a concern on the farm is whether the water supply to the cattle will freeze up; the first sign of this is a drop in the level of water in the drinking troughs. It's surprising how much water eighty cows need each day, and it doesn't take long for them to drain a trough once the supply is cut off. Once this has happened it's a case of boiling kettles of water and pouring them over the water valves and exposed pipes until they thaw and the water flows again. Despite our best efforts, it's not always possible to get all the troughs flowing and in some cases we have to transport water to the animals in 25-litre plastic containers – a tiring and time-consuming job.

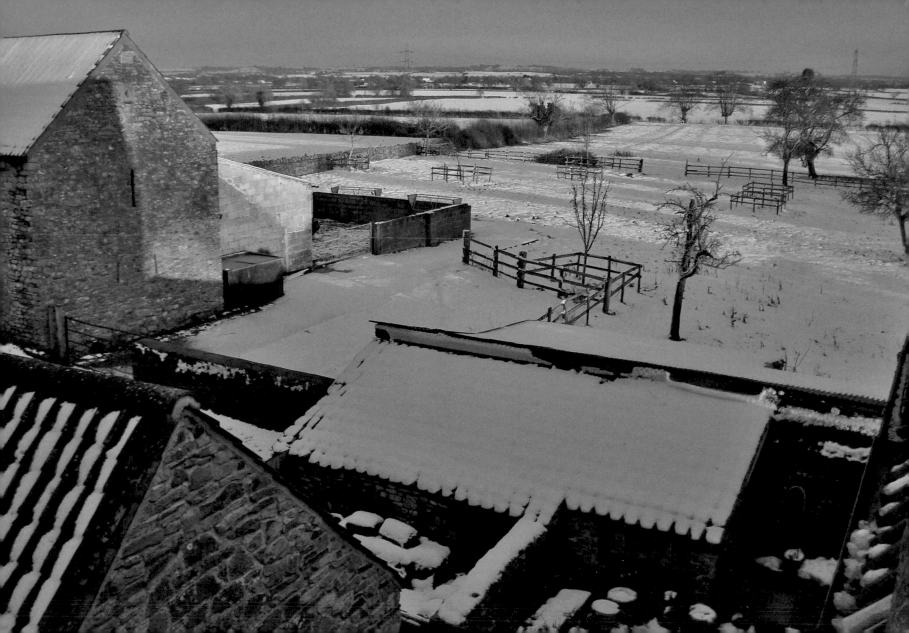

FEBRUARY

Throughout the year we receive regular bulk deliveries of cattle feed (cake) brought to the farm by lorry. The cake is a pelleted formulated ration made up of ingredients such as wheat, barley, palm kernel, soya etc, and has a specific protein percentage to match the rest of the cows' feed to ensure a balanced diet, healthy cows, and a good yield of milk. In the agricultural world there are several large, well-known companies that provide animal feed – and we have purchased feed from these at different times in the past – but for many years we have used a small, local, independent company called A. Nichols Cow Mills as they provide a good friendly service. In fact their rep Stan Hedges has been calling at the farm every fortnight at 10 a.m. on a Friday for over forty years. In the changing world of farming it's nice to have some stability.

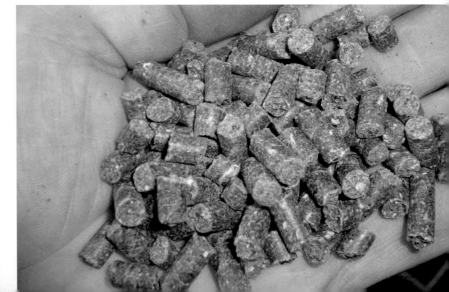

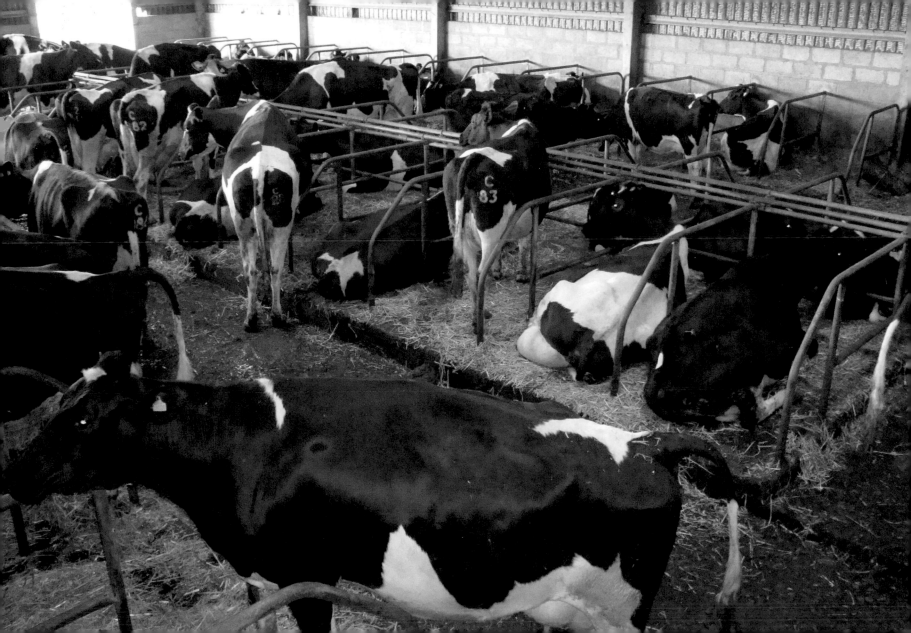

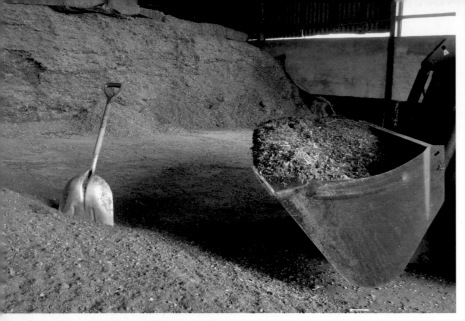

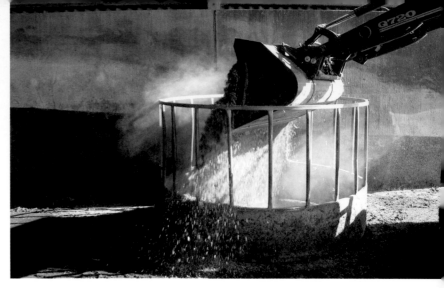

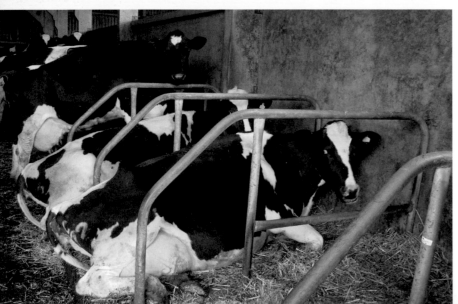

The cattle cake that is delivered to the farm is blown from the lorry by pipe up into a bulk bin before being augured into the milking parlour to be fed to the cows during milking. Each cow then receives an amount of cake according to the stage of pregnancy, yield of milk, and maintenance requirements. Outside of the parlour we feed the rest of the diet to our cattle by a very simple system. The cows have 24-hour access to the front of the silage clamp where they can eat from the exposed section of the silage (face). After the afternoon milking they are also given a mixture of maize silage and oil seed rape meal fed in ring feeders. On some other farms this feed is mixed in a wagon and fed down a long covered passageway, but the simple system we use seems to work and fits in with our low-tech style. The cows love maize silage and you have to watch your toes when you open the gate to let them in as they rush to be the first at the feeders. This mixture of forage and concentrates gives the cow a balanced diet that makes up for the lack of fresh grass that it would normally get during the summer months.

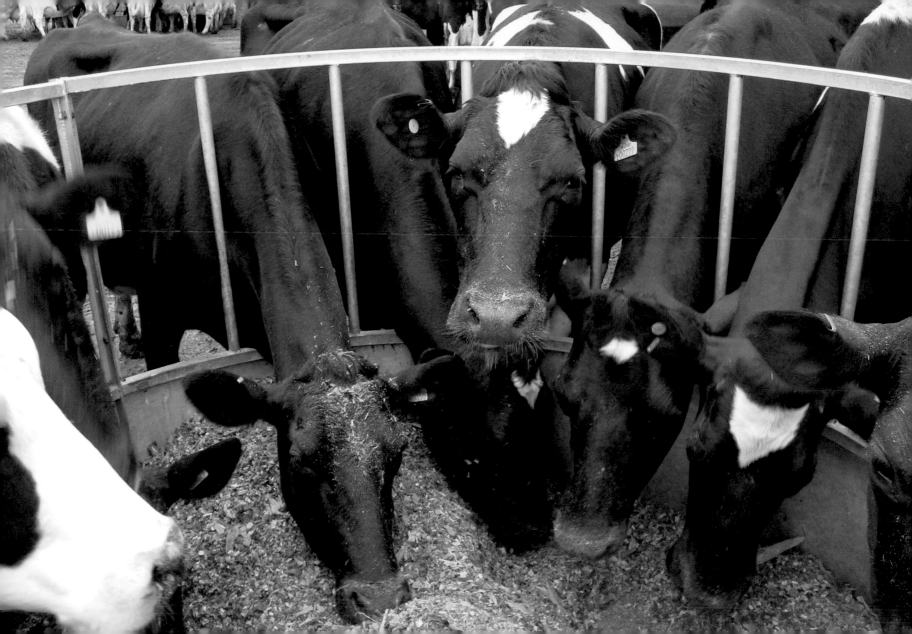

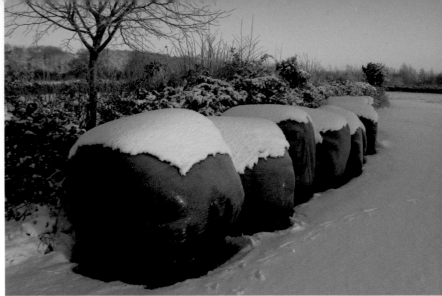

Towards the end of February there is a feeling in the air that spring is just around the corner. The mornings and evenings start to get lighter and it's noticeable that despite the cold weather the birds are starting to sing more and are increasingly active around the farmyard as they start to seek out a quiet place to build a nest. At this time the first bulbs are starting to flower, with snowdrops showing their heads before the arrival of the first green tips of the daffodil. Mother Nature still likes to keep you on your toes though and another late flurry of snow can soon make you realise that it's not time to put away the woollen socks, long johns or padded shirt just yet. Thankfully, the round bales of silage that we made during the summer are safely wrapped in plastic meaning that they are still good to feed to the young stock despite being left outside for the whole winter.

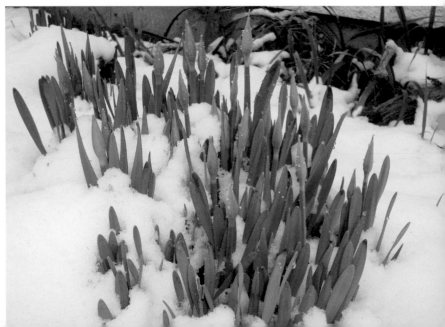

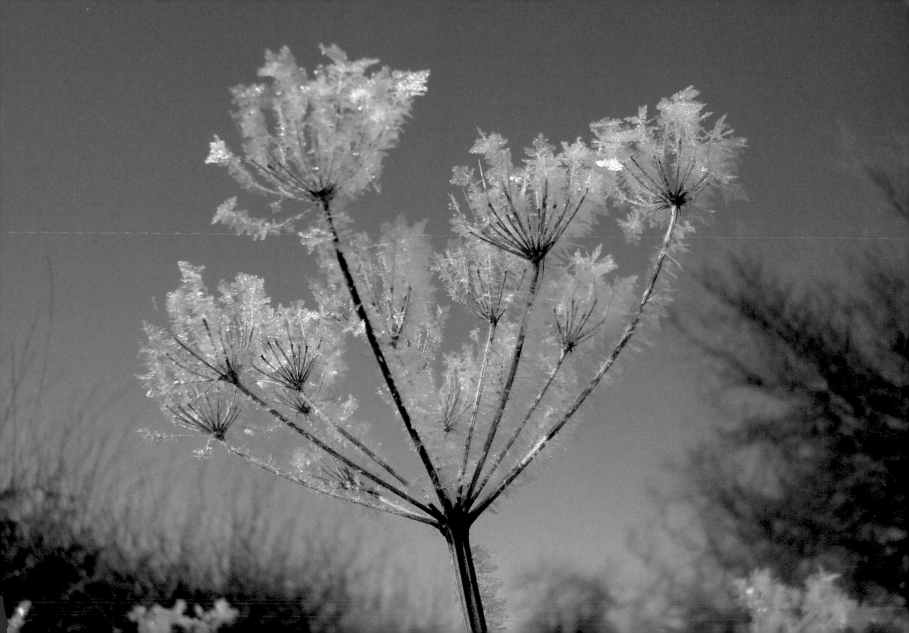

The two main activities during the winter months on a dairy farm are feeding and cleaning out/bedding down the animals. It's very important that the cows receive a good diet so that they are healthy and produce plenty of milk; however, it is equally important that their udders and feet are kept as clean as possible. Cattle lying on a dirty floor can get bugs in their udders which leads to inflammation and an infection called mastitis which makes the milk look like cottage cheese, rendering it undrinkable and unsalable. The other issue is foot problems such as dermatitis between the claws or foot rot in the hoof. These problems make the cow feel unwell, lose her appetite and reduce her milk yield, and while it's possible to treat mastitis with antibiotics or dermatitis with regular foot bathing, prevention is definitely better than cure. For this reason the cattle are bedded down with fresh wheat straw in their housing twice a day. The cattle's winter quarters consist of a yard and a building containing individual cow compartments called cubicles, which have a rubber mat for them to lie on. The cows have free access to these cubicles so that they can choose to lie down at any point during the day and night. The passageways between these cubicles are used by the cattle to walk around the building and are cleaned out twice a day with a large yard scraper mounted onto the back of a tractor. In our case, we use a Massey Ferguson 135, which has been doing reliable service on the farm for over forty years and seems to always start in the morning whatever the weather. The muck that is scraped from the passageways and yard is pushed up a ramp into an awaiting muck spreader; from here it is then taken out into the surrounding fields and spread thinly over the grass. This returns valuable nutrients, minerals, and organic matter to the land ready for the next crop of grass and so plays an important part in reducing the fertiliser requirement for that field.

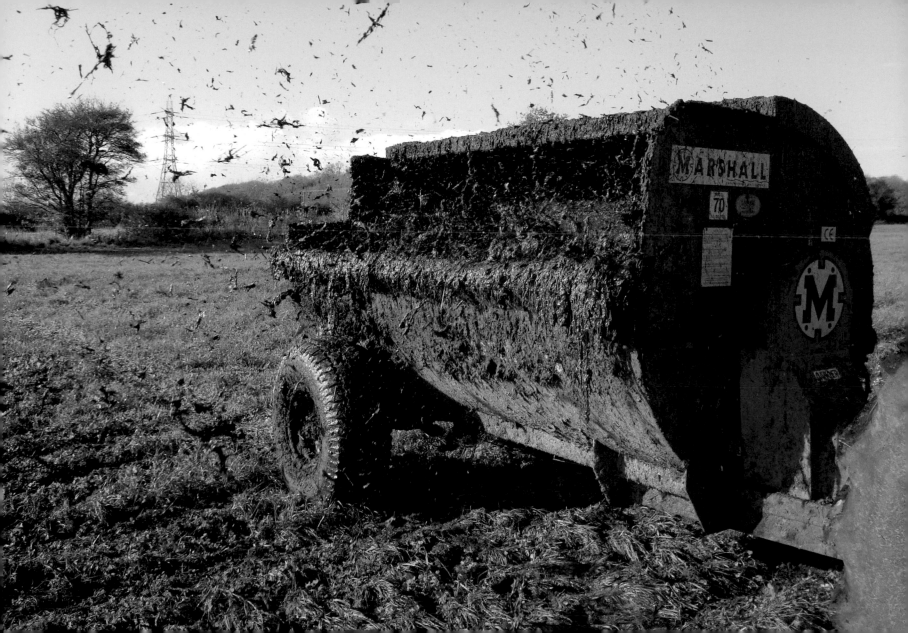

Our farm consists of a lot of small fields surrounded by thick hedges made up mostly of hawthorn with a mixture of, amongst other things, Ash, Elm and Oak. These hedges form an excellent barrier to prevent cattle from escaping to the next field as well as providing a home for all sorts of wild life and insects. Much like plants in a garden, the hedges require some maintenance to keep them in good condition and it is important that they are trimmed at regular intervals to keep their shape and to encourage them to bush out with new shoots. If they were left to their own devices the hedges would soon grow into a row of trees and not be very stock-proof. Trimming of these hedges can be done in any of the winter months but must be completed by law before 1 March so that no nesting birds are disturbed. We have a lot of hedges on the farm and trimming them is time-consuming job; I can spend over a week going up and down the hedgerows. As part of our environmental scheme we trim the hedges every two years instead of every year, which is the norm. This gives the hedge a chance to produce a greater amount of autumn fruits such as sloes, blackberries, and rose hips, which provide valuable winter food for the birds, and greater cover for nesting in the summer. Rotating the trimming of these hedges so that half the farm is done one year and the other half is done the next also means that at any one time there is always plenty of cover for the birds to shelter in. During hedge trimming I also keep an eye out for any young saplings that may one day make a good tree; by trimming round these you can produce some very nice hedgerow trees in a few years.

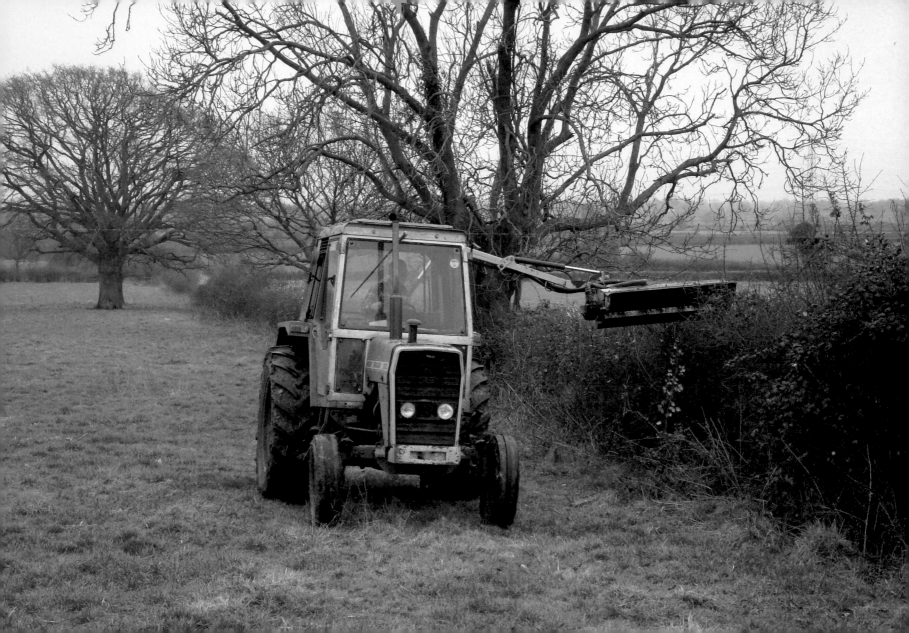

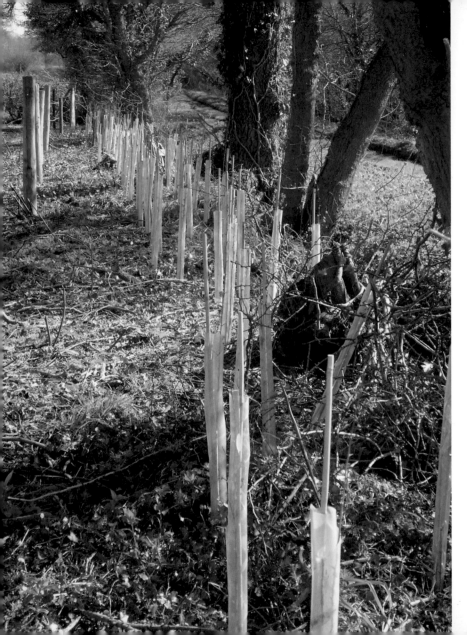

MARCH

Throughout the winter months, we try to carry out a variety of conservation work on the farm such as pollarding, hedging, and tree planting. March is the last month before spring when this work is carried out to avoid disturbing nesting birds.

To ensure the hedgerows continue to be stock-proof they require regular maintenance in the form of hedge trimming. However, when a hedge becomes old and full of gaps it is better to lay this hedge to encourage it to regenerate and keep bushy and healthy.

To lay a hedge you first need to clear out any brush, dead, or unsuitable wood from the base of the chosen hedge. Once this is done each upright stem is cut at an angle about 6 inches above ground, leaving enough stem to allow it to bend over and be laid. This process is continued down the hedge with the next stem being laid on top of the preceding one. Once finished, the hedge should be fenced to give it time to recover; it should then form an impenetrable barrier to stock. If the hedge has died out in places it is also a good time to replant it with 50 per cent hawthorn and a 50 per cent mix of hazel, maple etc. Until they are established, these new plants are surrounded with plastic spiral guards to protect them from rabbits, and staked with bamboo canes to prevent them from blowing over.

Like many other birds on the farm at this time of year, the rooks start building their nests, which appear high in a group of oak trees – tradition has it that this will indicate a good summer.

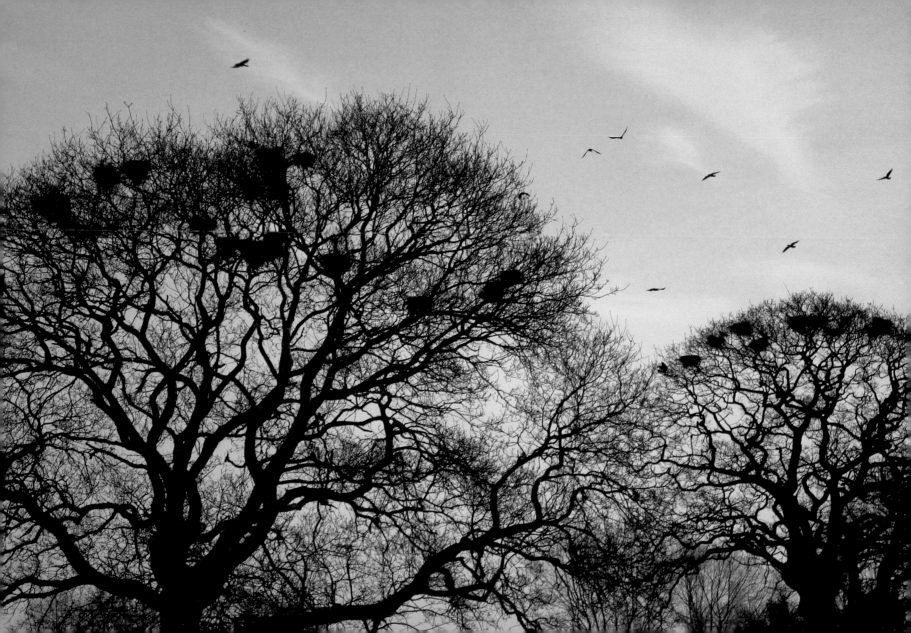

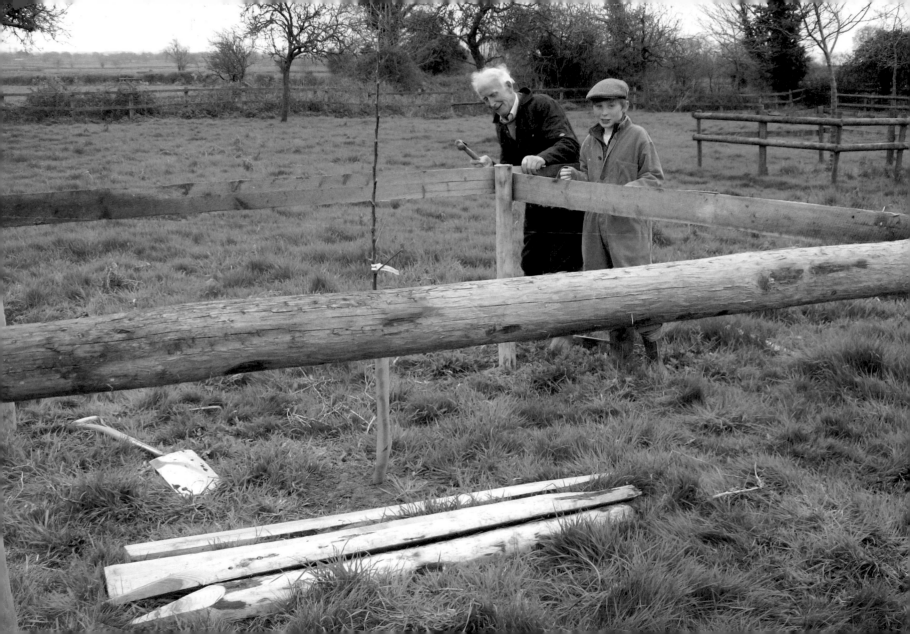

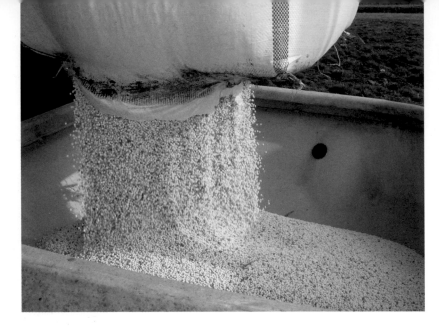

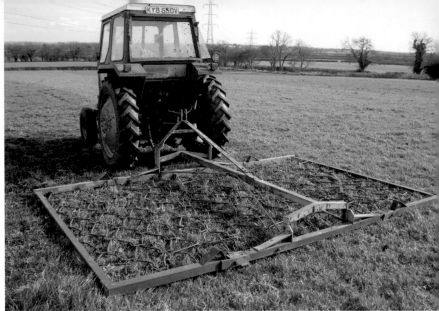

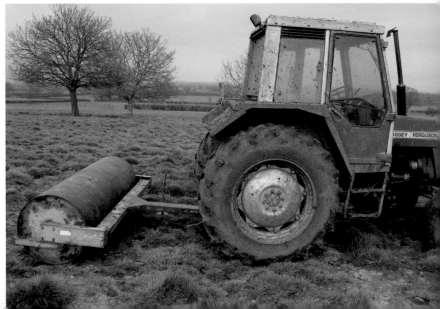

March is the month when many parts of the farm are prepared for spring. The fields are chain harrowed to spread out any lumps of manure or mole hills and to break up any dead grass. Following this, the fields are rolled to flatten out any raised areas. These two operations should ensure that the grass density is improved and the fields are easier to drive on when carrying out operations.

After chain harrowing and rolling, the grazing and silage fields receive an application of fertiliser. This fertiliser is supplied in 600 kg bags and is a balanced mixture of nitrogen, phosphate, and potassium. Nitrogen increases plant growth, phosphorus increases root growth and promotes early plant vigour, while potassium aids photosynthesis and growth. We use this artificial fertiliser to complement the nutrients the grass receives from the manure we put on the fields so that the grass gets a good start in the spring.

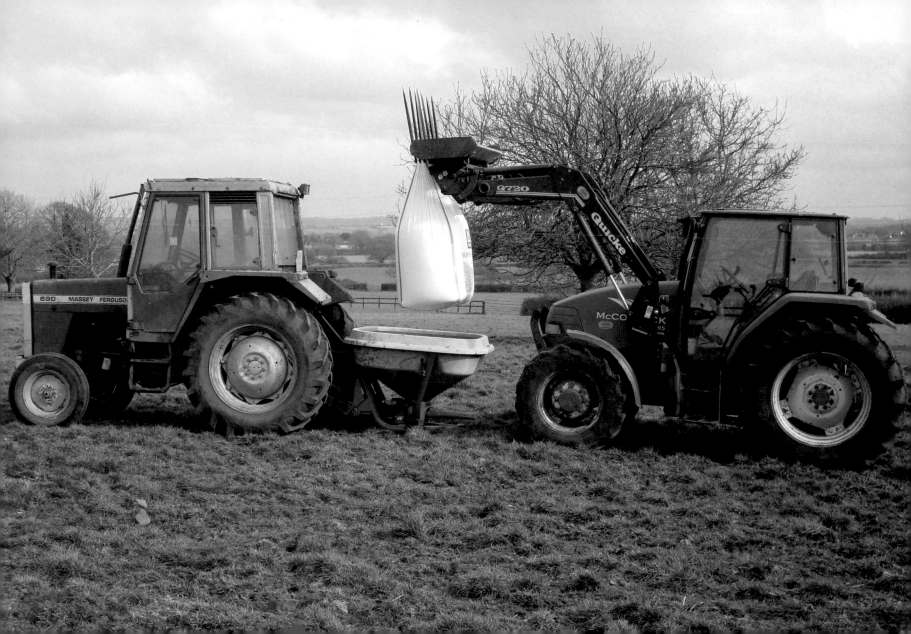

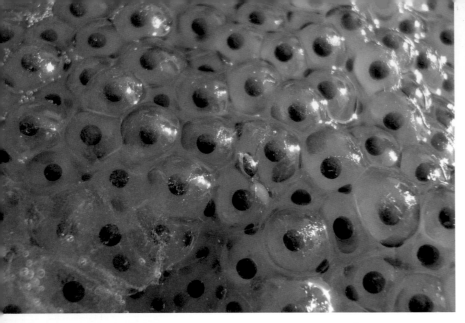

After the cold dark months of January and February it's a relief to see the first signs of spring on the farm. In one of the ponds a large group of frogspawn has appeared. It has been estimated that a female frog can lay up to 4,000 eggs at a time, although only a fraction of them will survive to maturity. Each egg contains a tiny cell which over a few weeks will develop into a tadpole, before emerging from the egg's protective jelly to continue its development into a frog. The change from tadpole to young frog takes about twelve weeks.

Primroses are the earliest spring flower on the farm and appear in clumps in shady hedgerows. This attractive flower is a perennial that has edible flowers and leaves. The flowers can also be used to make primrose wine. Pussy willow in the hedgerows produces catkins covered in a greyish fur. These attractive male catkins are favoured by flower arrangers who use them in spring displays.

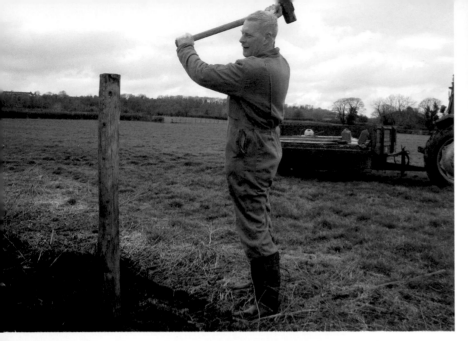

In readiness for the spring turnout of the cows, the fences around the farm are checked and any rotten fence posts are replaced with new ones. Although treated with preservative, the fence posts only last about ten years before they need replacing. We buy the posts in bundles of sixty and will use most of these along with a reel or two of barbed wire during the spring maintenance of these fences.

As well as repairing the fences, we also have some of the drainage ditches around the edge of the fields cleaned out at this time of year as they become silted up over time. To clean out the ditches we call in the local contractor who brings in a JCB. This will be the first of many visits to the farm over the year by the contactor to carry out various farming operations. Like many farms, we don't have the time to do all the work ourselves and it's not economically viable to own all the machinery required; A. G. Sansum and Sons, a local contractor from the neighbouring village of Cromhall, provides us with a good reliable service for the work we don't do ourselves.

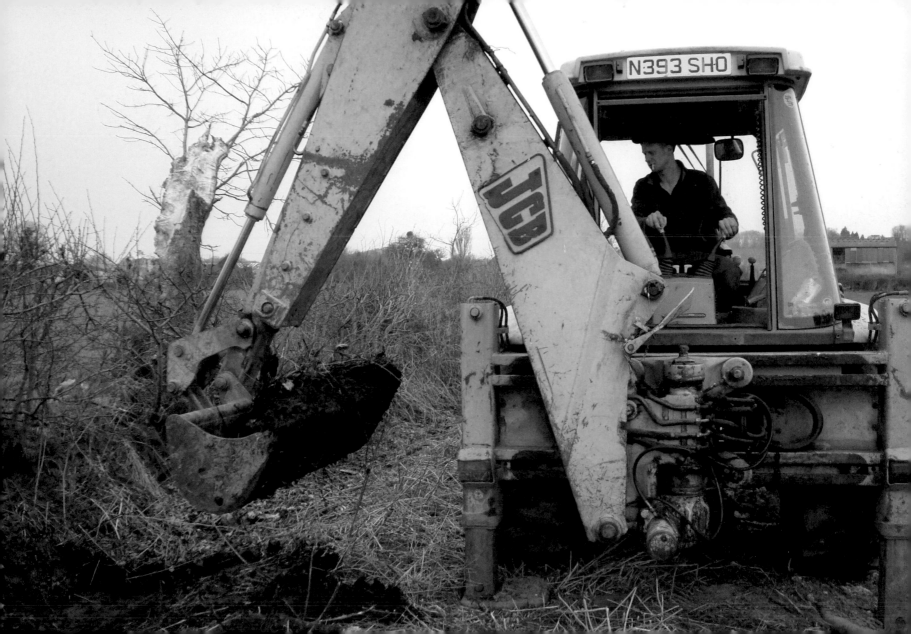

APRIL

Over the previous month it's noticeable that the cattle are getting impatient to get back out into the fields; they spend more time out of the shed and looking over the gate to the green fields beyond. It's a relief to both us and the cows when the grass is deemed long enough to graze and we can at last open the gate to let the cows out. It really is quite a sight to watch them all rush out and skip with glee around the field like children let out of school after a long day.

Just before the cattle are turned out to the fresh spring grass, any young animals that have recently entered the herd are freeze branded with a number to make them easily identifiable. This mark is created by dipping an iron into dry ice and alcohol, which has a temperature of -180 degrees. By holding the iron onto the cows rump for a minute, the pigment cells in the hair follicles are destroyed and the hair grows back white and in the shape of the number or letter chosen. Unlike the old fashioned method of using a red hot branding iron, this method causes the animal no pain, just a mild discomfort.

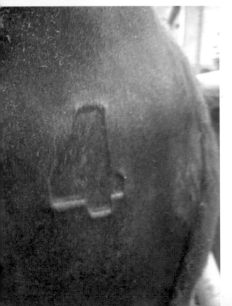

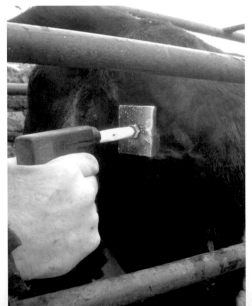

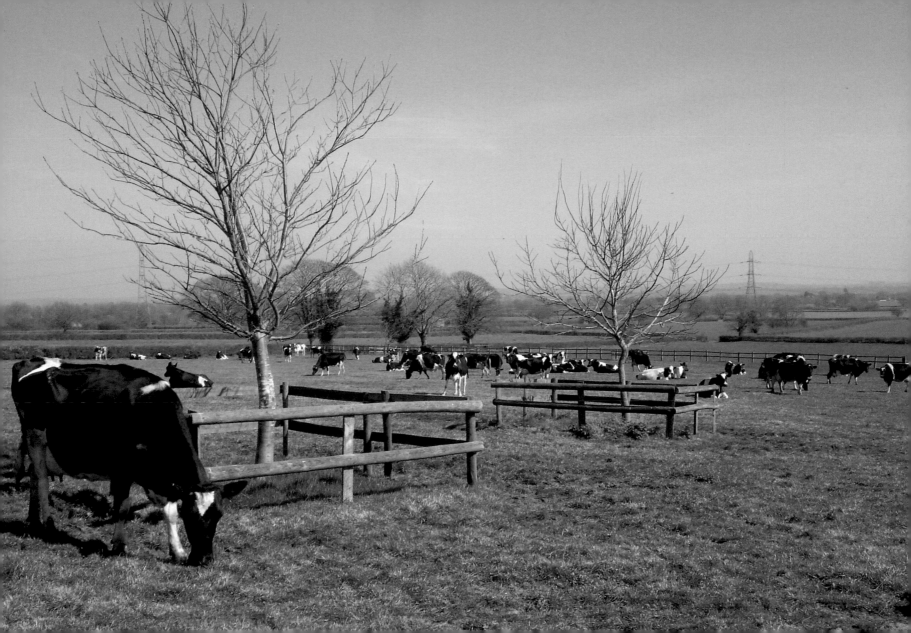

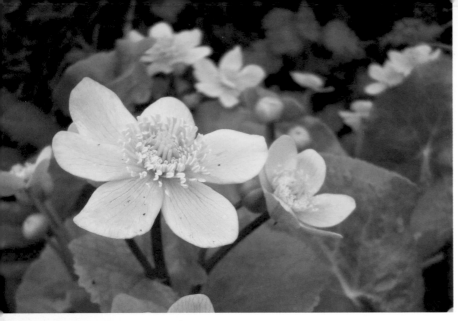

The warmth of the spring sunshine starts to bring the hedgerows, banks, and fields of the farm to life and where there had previously only been bare twigs, piles of old leaves, or blades of grass, there are suddenly displays of all sorts of wild flowers. Flowers such as the celandine appear in the hedgerows and field edges, while on the sides of the stream the marsh marigold appears seemingly from nowhere to provide large golden clumps of flowers.

In the small piece of woodland we have on the farm, the bluebells awaken and put on a beautiful display. You have to catch the bluebells at the right time as they only appear for a few weeks; a visit to the bluebell wood is an enchanting experience for young and old.

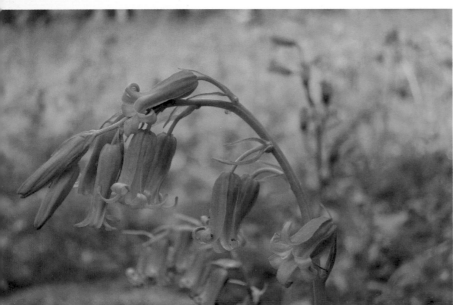

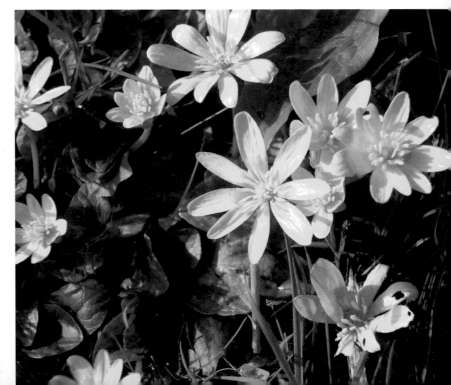

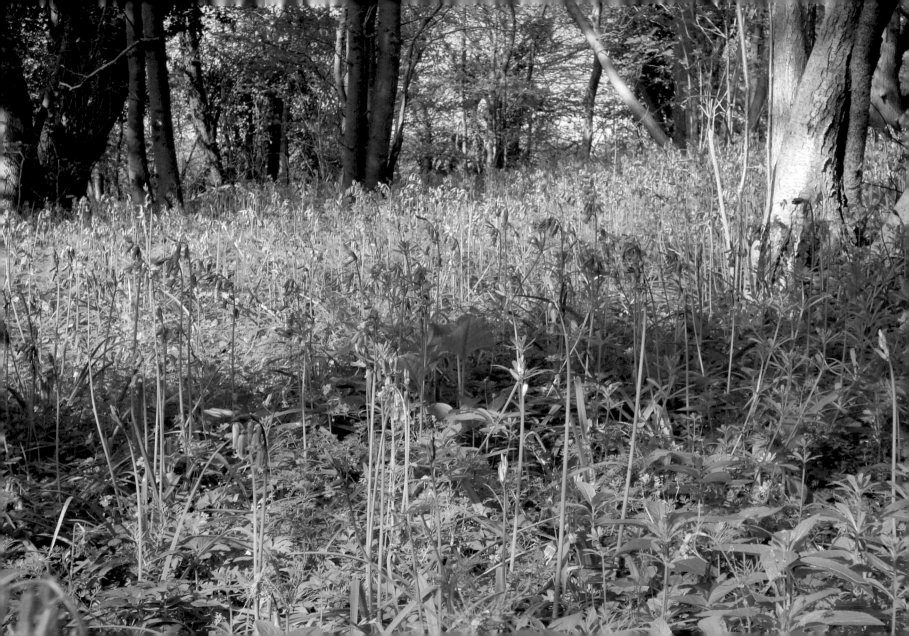

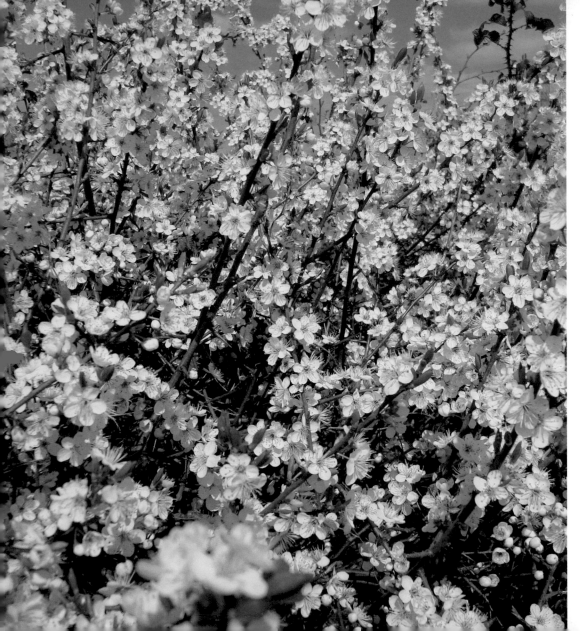

By mid-April the soil has warmed up enough to plant the maize seed that will eventually produce next year's winter feed for the cows. Before ploughing, the field is given a good covering of manure to give the crop plenty of nutrition; this usually involves my brother and me spending several days going back and forth with loaded muck spreaders. After this the local contactor comes in with his five-furrow reversible plough. When you watch this machine in action it's hard to believe that my father can remember when this task was done by a man walking behind a plough and a shire horse.

As the first flush of spring flowers die out, the second wave of blooms can be seen around the farm. In the hedges, clouds of white flowers from the blackthorn bushes cover the otherwise bare branches, while, on the common land that we manage next to our farm, cowslips appear in several small clumps. These are a rare sight and are one of my favourite wild flowers with their delicate yellow bells. Unfortunately, several passing motorists have also taken a liking to these in the past and on a few occasions I have found that someone has dug out several plants and taken them, presumably to put in their garden. The cuckoo flower also makes an appearance towards the end of April. This is a pinkish white flower that grows on some of our grassland; it especially thrives on the hay meadows as it benefits from the late cutting of the grass.

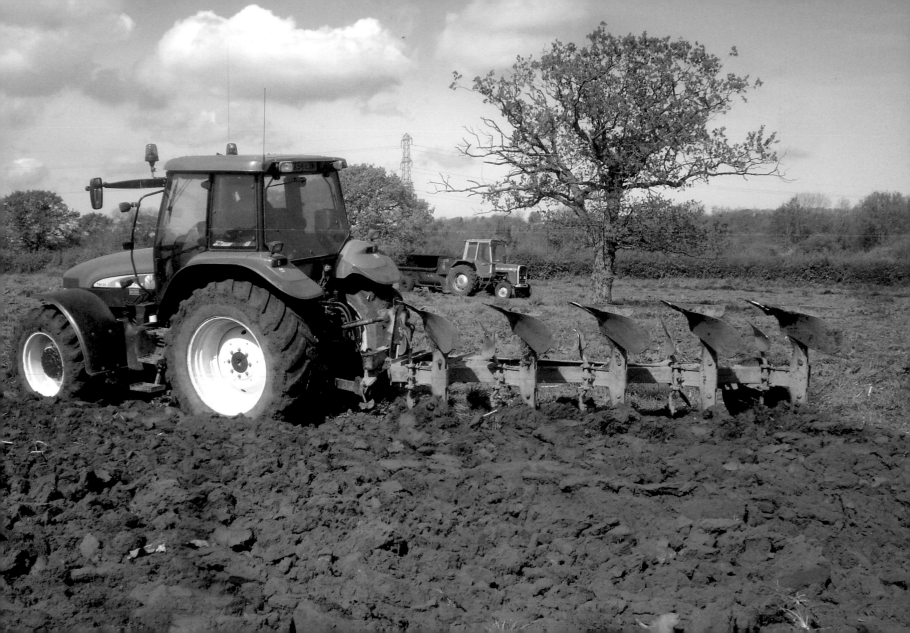

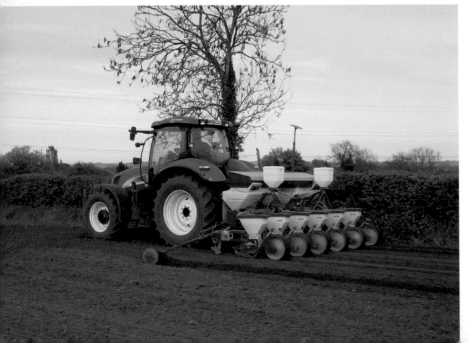

Once the maize fields have been ploughed, the soil is then worked using implements such as a power harrow that breaks up clods and lumps of soil to form a fine seed bed. It is important that the weather is fine during these operations or the seed bed will form a sticky mess and make it difficult to work. The variety of seed selected depends on crop requirements, i.e. early maturing, dry matter percentage etc; in our case we use a variety called Justina which is a great all-rounder. The maize seed is then planted using a seed drill to a depth of 8–10 cm in rows about 60 cm apart, averaging 42,000 seeds per acre.

Maize is an expensive crop to grow and it is important that the plants are given the best chance to survive and thrive. As well as ensuring the plants are given the best growing conditions, it is also important to try to minimise the loss from pests. Crows take a particular liking to maize seed and will walk along a row of freshly-planted seeds, eating as they go. For this reason the seeds are coated with a red bird repellent that makes them unpalatable.

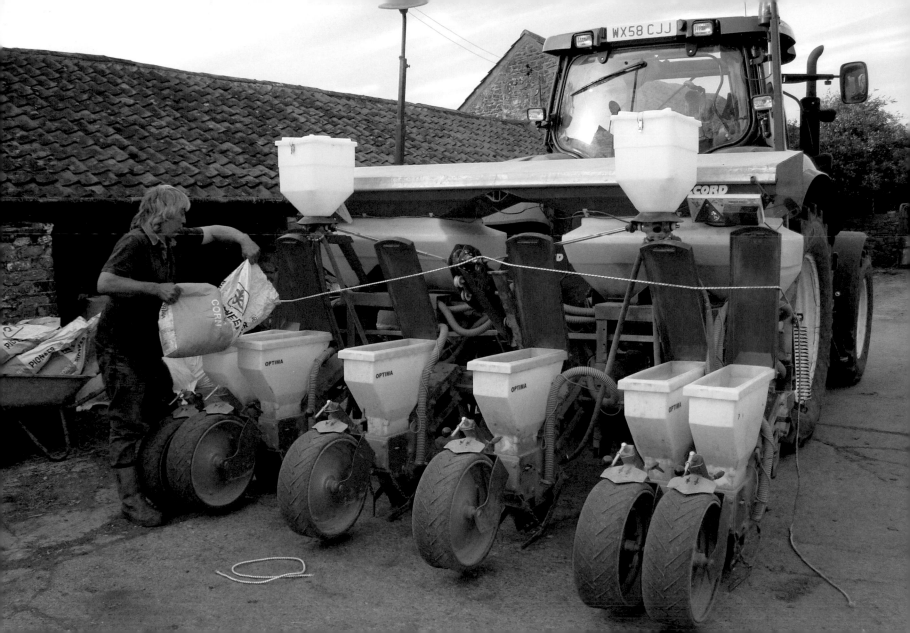

From the hill overlooking the farm a glorious view of bright yellow can be seen as the neighbouring farmer's oil seed rape comes into bloom. When harvested, the oil extracted from the rape seed will be used in bio fuel. The farming method of the neighbouring farm is in marked contrast to ours in that their fields are much larger with fewer hedges to allow for the large machinery involved with arable crops.

At this time of year the farm's orchard also comes into bloom; the apple and pear blossom come alive with bees, and on a windy day the air can be filled with confetti as the blossom falls. In my opinion every farm should make room for a few fruit trees – they add something to the place – it's being able to see these flowers and trees in bloom that help to make your day enjoyable and forgive the unrelenting winter for its harshness.

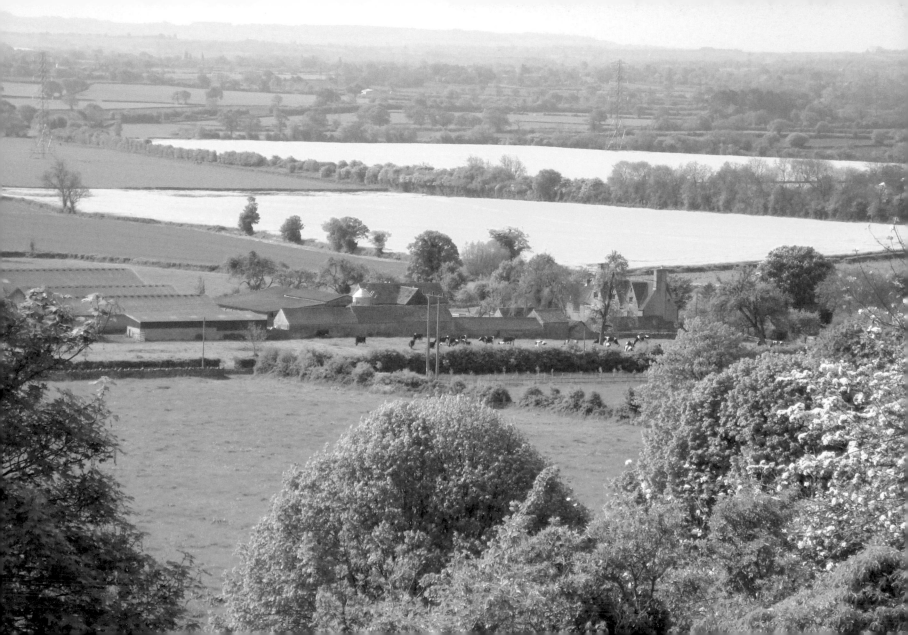

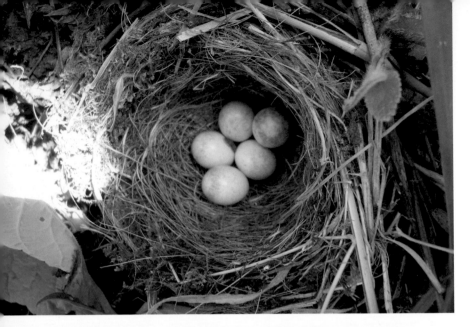

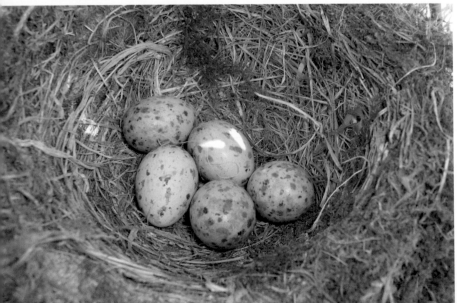

MAY

One of the delights of the farm is the wide variety of birds that live in the trees and hedgerows; during a walk around the fields it's possible to see a gold finch, thrush, blackbird, barn owl, or even a buzzard circling high in the sky. At this time of year many of the birds are nesting and you have to be careful when moving a bale of hay in the barn in case a wren or robin has decided to start a family in a convenient hole or crevice. It's amazing how these small birds can make such perfect round nests by weaving together grass and moss from around the farm using just their beaks. The nests pictured contain robin and mistle thrush eggs; quite aptly, the mistle thrush laid its eggs in the middle of a clump of mistletoe in one of the apple trees in the orchard.

The red campion flower appears in shady hedgerows at this time of year, and has delightful delicate pink flowers. There is also a white variety of this plant which can sometimes be found for sale as a garden plant.

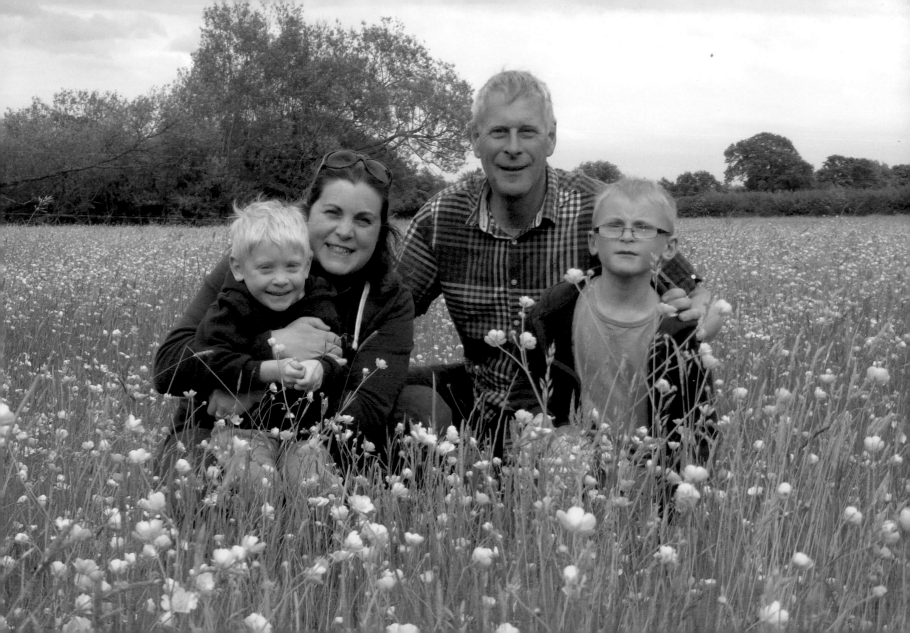

During the 1970s, the farm lost a large number of elm trees due the ravages of dutch elm disease. Before this time, every hedgerow would have had its share of these great trees, but sadly when the disease struck these all died in a short period of time and were either sold off for their timber or logged for fire wood. The loss of these trees left many gaps in the hedges and left the farm looking quite bare. Sadly, so far it has been impossible to get any elms to grow on the farm as despite plenty of suckers growing in the hedges, once they reach an age of about ten years they too succumb to the disease. Therefore, over the years we have planted trees such as oak, lime, and chestnut, and have encouraged new trees to grow from self-sown saplings found in the hedges. The pictured tree is a horse chestnut which was planted as a conker thirty years ago. At this time of year the hawthorn in the hedges blossoms and gives a vibrant display of small white flowers; these will eventually provide the red autumn fruits that the birds will eat over winter. The biennial trimming of the hedges increases the amount of flowers and fruit on these hedges.

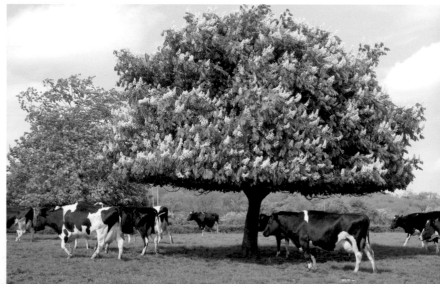

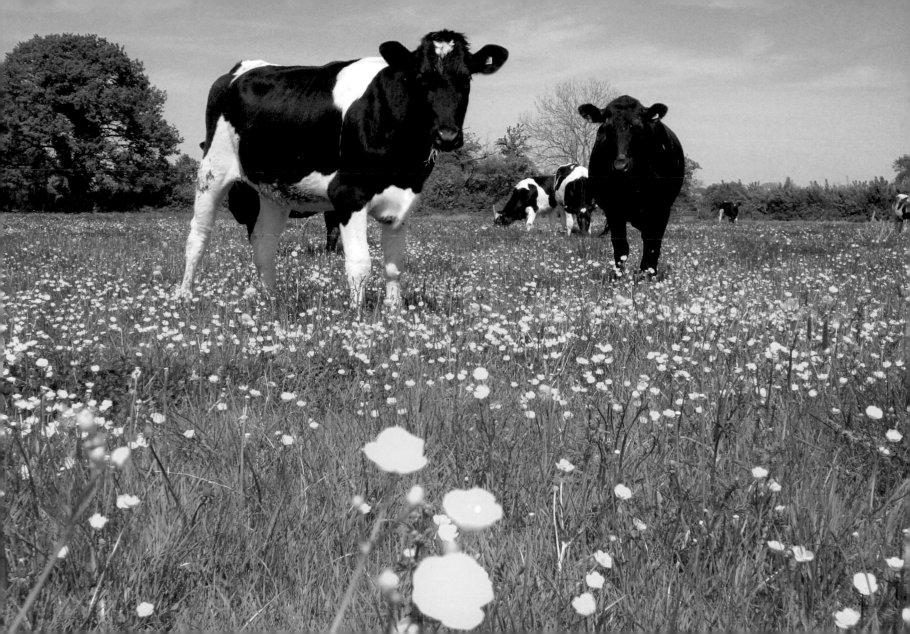

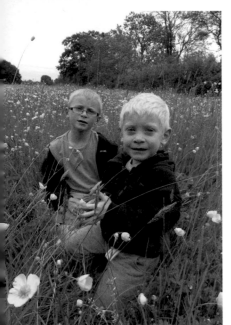

Whilst the cows contentedly graze the fields near the farmyard, the hay meadows further away are left to grow in preparation for haymaking. These hay meadows are classed as semi-improved grass land, i.e. they are old fashioned leys of grass with a rich variety of grasses and wild flowers. Years ago, this sort of meadow would have been common throughout England, but with the intensification of farming 95 per cent of these have been ploughed up or replaced with higher yielding short-term grass leys containing rye grass. Only small pockets of this sort of grassland can now be found around the country; it is only relatively recently that these old meadows have been appreciated for their rich biodiversity and efforts have been made the conserve them. On our farm we have three fields that are classed as semi-improved and they are managed as part of our environmental scheme to conserve and enhance them. They receive no fertiliser or additional applications of manure other than from the cattle that graze them; this reduces the nutrition in the soil thus allowing the flowers to compete with the grass. Unlike silage fields, the meadows are cut later in the year (usually July) allowing the wild flowers to seed. As you can see from the picture, there is a stunning display of buttercups at this time of year, although many more species of flowers appear throughout the season such as cuckoo flower, greater burnet and knapweed. Attracted by the nectar in these flowers, it is possible to see hundreds of brown butterflies dancing over the grass when walking through these meadows on a sunny day. Whilst these fields produce much less grass than other areas of the farm, they are by far the most interesting places to spend some time and I feel it is important to conserve them so that future generations can also enjoy them.

Pictured in the meadow are my two sons, Jack (aged seven) and Harry (aged four), who are enjoying this wonderful field.

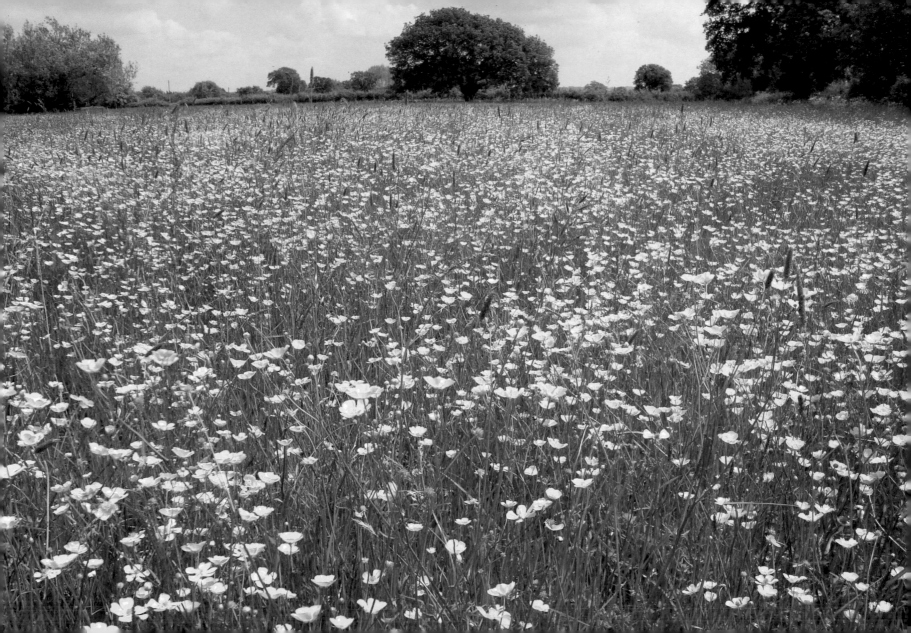

Within a few weeks of planting the maize, the first sign of the germinating seed appears as tender green shoots break through the soil. The picture opposite, which was taken at the end of May, shows clearly how accurately the drill places the seed in the rows; there are no overlaps or misplaced plants.

Possibly the most important time of year on a dairy farm is the period set aside for silage making. Silage is basically grass that has been cut, wilted, then stored in an air tight environment (clamp) where it pickles to form silage. It's vitally important that the best quality silage is made as this is the winter feed for the dairy cows for 5-6 months of the year, and will affect how much milk they will produce during this time. The first cut of silage is usually made in mid-late May, when the grass has both a decent amount of volume and a good amount of sugar in its stems. At this time, forecasts are checked for fine weather, and neighbours' hedges are peered over to see if they have started cutting yet. Once a decision is made to cut the grass it is all systems go. My brother and I will spend a day mowing all the fields required; the grass is then left to wilt for 24 hours before the contractor arrives with his team. They then use a self propelled forager to pick up the grass; this chops it and blows it into the trailer driving alongside. Once the trailer is full it is driven back to farm. There are usually three tractors and trailers running at once, providing a constant cycle of trailers either being filled, emptied, or in transit.

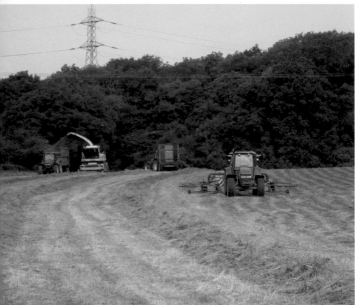

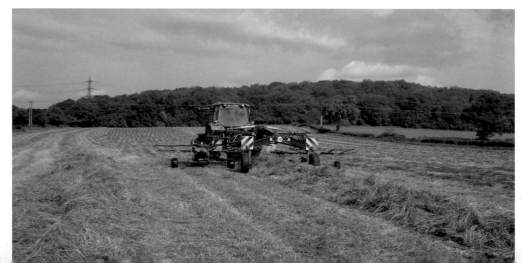

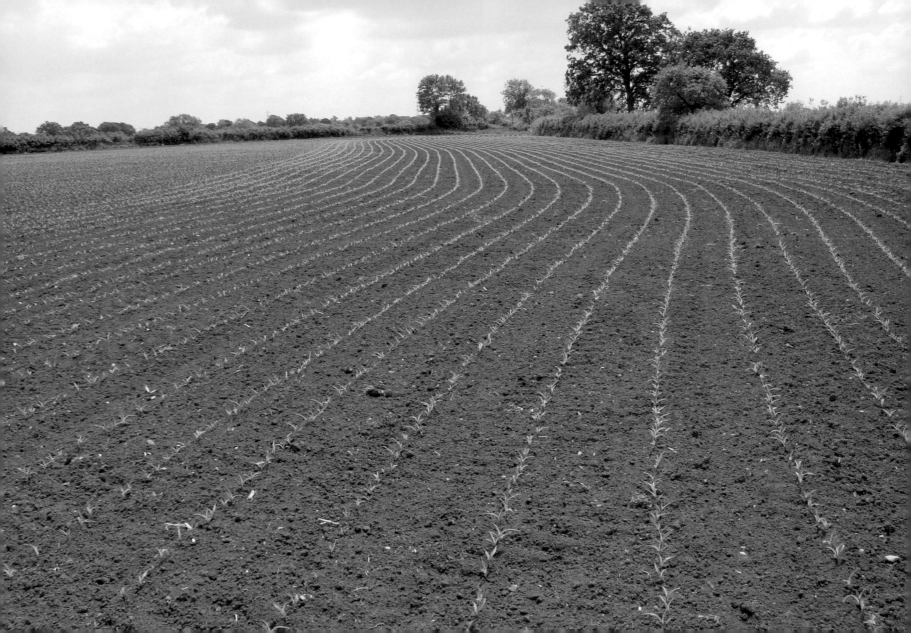

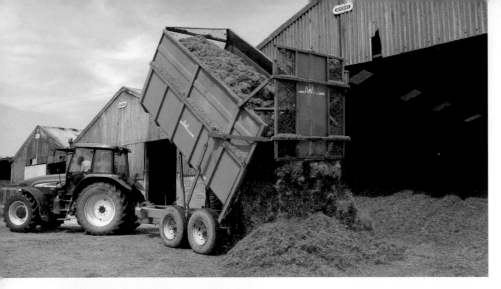

Once the loads of silage are back at the farm they are tipped and the contents is pushed up into the silage clamp using a JCB telescopic handler which is fitted with a loading fork. The silage is spread evenly into the clamp and constantly rolled to exclude the air as the layers build up. The more the clamp is rolled the better as the exclusion of air prevents the silage from rotting. Once the clamp is full, the silage is given a final roll before a black plastic sheet is placed over the top; this sheet is then sealed at all the joints with tape to try and make it as air tight as possible. Finally the sheet is weighted down with hundreds of old car tyres and straw bales.

During their time on the farm the contractors act as a team and work flat-out to get the crop in as quickly as possible to ensure its quality. Once finished, they quickly move onto the next farm in the queue for silage making. These days most farms have only a few people working on them and the arrival of the contractors reminds you of what it must have been like 100 years ago when every farm had a group of men working full-time all year round. Those days would have been hard, but perhaps better for the camaraderie that must have existed between the workers.

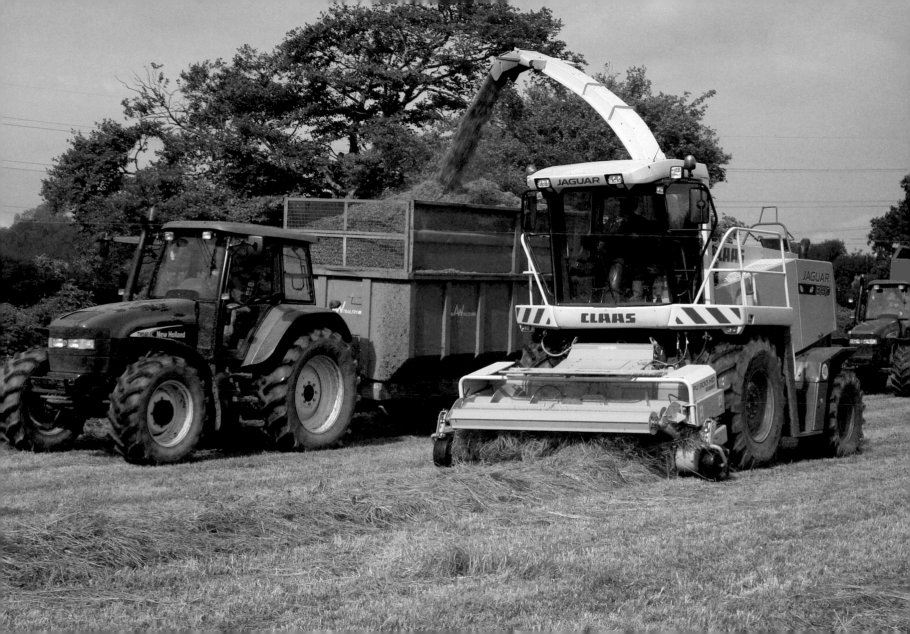

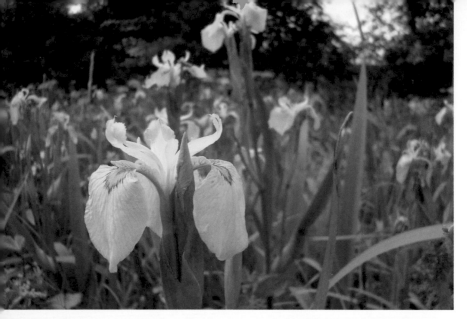

JUNE

From spring onwards a wide variety of wild flowers appear throughout the farm. The month of June is no exception to this, and it's always a pleasure when walking around the fields to see the pink dog roses in full bloom in the hedges. In a few short months, these flowers will have turned into the brightly coloured rose hips that will provide a bright red autumn display and much needed winter food for the birds.

Wild honeysuckle also flowers at this time of year. As it climbs through the branches of the taller hedges, it's often hard to believe that this is a wild plant, especially when it has been adopted by so many gardeners.

On the common, the flag irises which thrive in one of the damp areas near the stream turn a bright yellow and provide a lovely backdrop to other wild flowers there. The rhizomes from these plants were traditionally used as a herbal remedy, most often as an emetic which induces vomiting and is used medically to expel a toxic substance that has been swallowed.

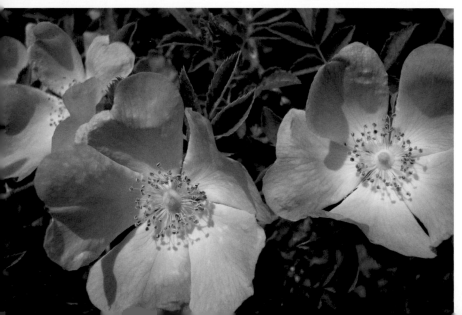

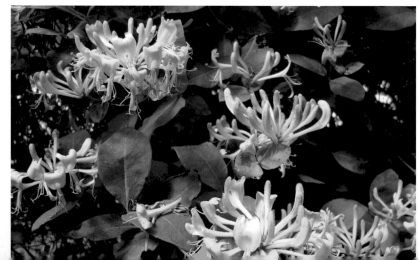

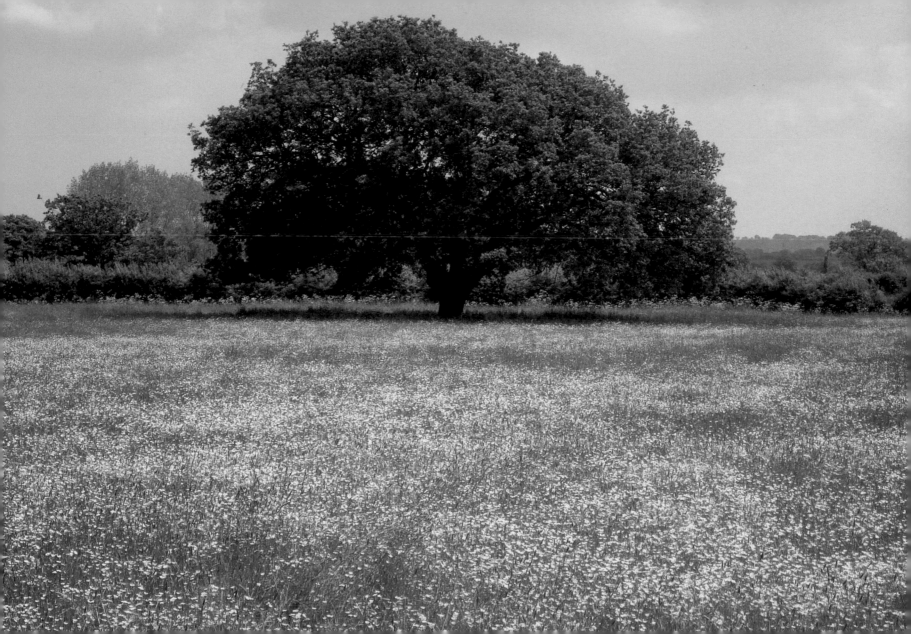

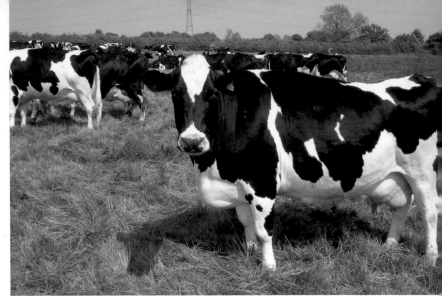

With the long winter months behind us and all the cattle out to grass, the cows settle into a routine of grazing and milking. The cows are given a fresh piece of grass every day and once they have grazed the whole field they are moved to a new field to allow the grazed pasture to freshen up. The dairy herd is kept in the fields nearest to the farmyard as these are the best grasslands and you don't really want to have to walk too far in the morning to get them in for milking.

Milking is carried out twice a day, at 6 a.m. and again in the afternoon. The cows get used to this routine and start heading to the milking parlour when called. It's possible to stand at the top of a field and give them a call of 'HUPHUPHUP, COOOOME ON THEN, HOHOHO' and watch them all start to rise and move *en masse* towards the farmyard. Funnily enough, when the clocks go back to Greenwich meantime in October, they will often be waiting at the gate in the morning as if to say 'come on, you're late'.

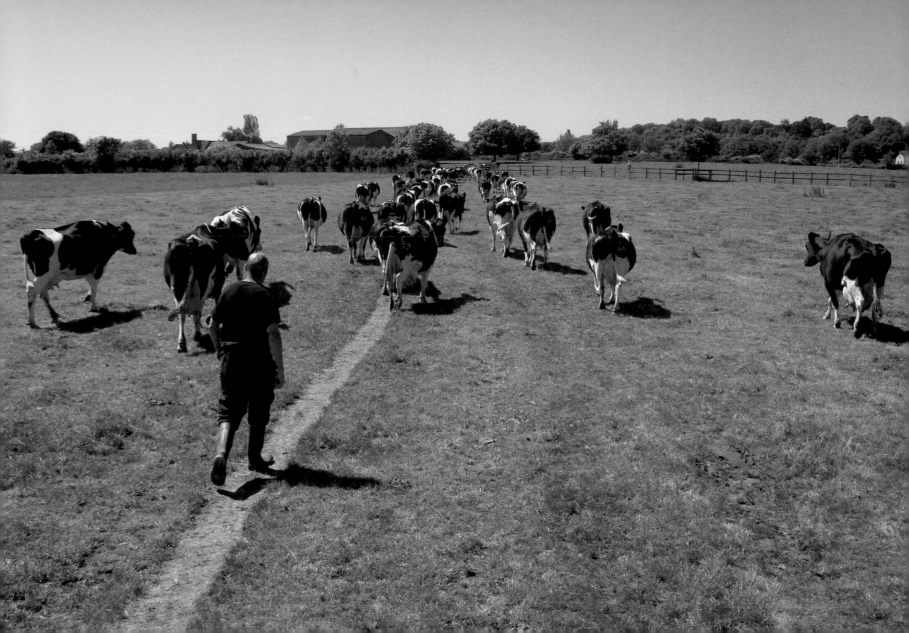

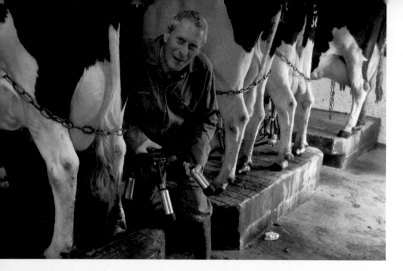

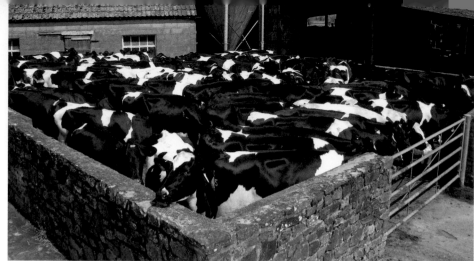

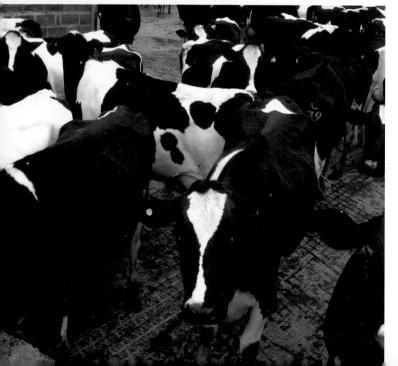

The cows come into the farmyard in a seemingly random order, yet surprisingly they have a pecking order when they come into the milking parlour. Some cows will always come into the parlour near the start of milking while others will always hang back to the end and no amount of coaxing will encourage them to change that preference.

Once in the parlour, each cow is given a quantity of feed (cake) which is part of their balanced diet and also helps to keep them happy whilst they are being milked. Before milking, the cows' teats are cleaned and a sample of milk is taken to ensure there are no problems such as mastitis. Once this is done, it's a relatively simple job of just putting the milking units onto the four teats and leaving them there until the cow has finished milking. The cows don't mind this daily routine and usually stand contentedly while it goes on. However, occasionally there can be problems when a new young cow (heifer) first comes into the parlour; it can take a lot of coaxing to get her into place and quite often the milking unit ends up being kicked off the udder until she gets used to it.

The family line-up of my father Bill, brother Tom, and myself shows us all standing by the collecting yard ready for milking. We all share the responsibilities on the farm and take it in turns to get up first to start the milking.

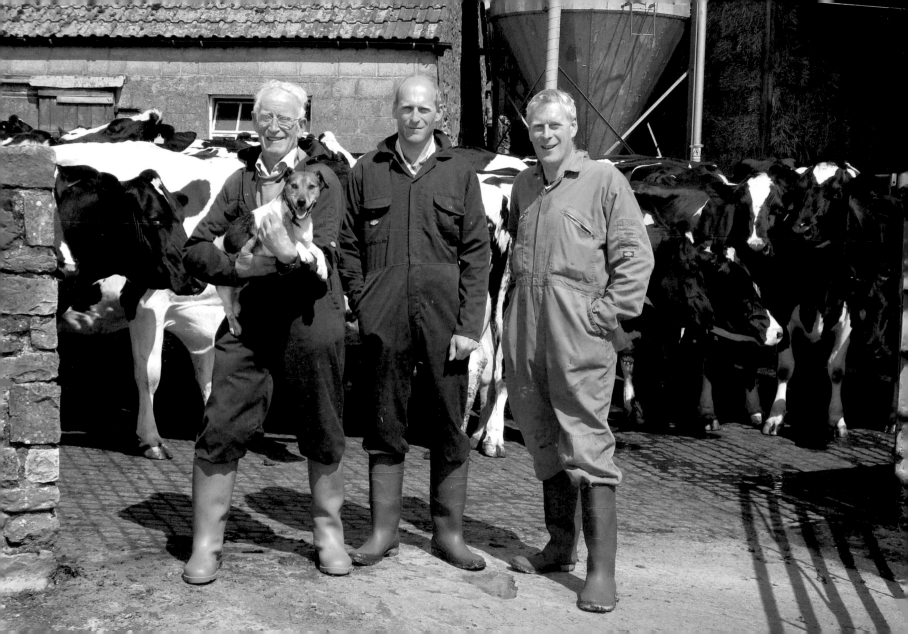

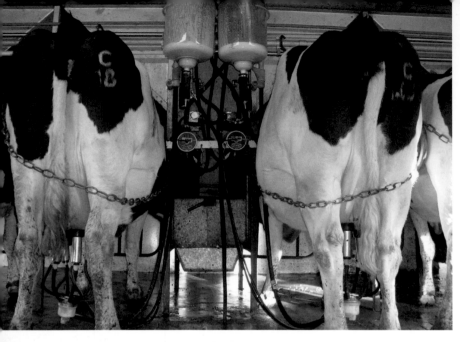

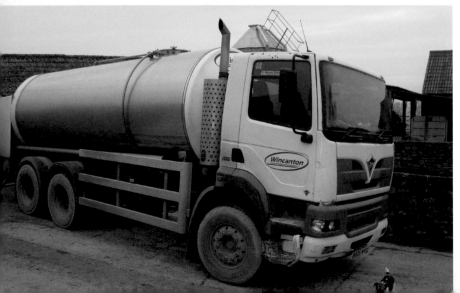

The milking parlour we use is called an abreast parlour; these are now considered to be quite old-fashioned and have been superseded by herringbone and rotary parlours. These newer style milking parlours essentially do the same job as ours but the lay-out of the parlour is different and they can cope with a much larger number of cows at milking time. For the time being, the milking parlour we use does the job, but it is slow compared to other parlours and at some point in the future it will have to be replaced.

Once the cows have been milked, their teats are dipped with an iodine solution to prevent infection before being let back out into the fields; meanwhile, their milk is piped along to a large stainless-steel tank where it is cooled to around 3°C. The bulk tank holds two days worth of milk, and is collected by tanker every other day before being taken to the dairy in Stonehouse near Stroud, where it is processed. During the spring months when the grass is young and fresh and the cows are producing a lot of milk we nearly fill the tank to the brim by the time the tanker comes to collect it – a quantity of over 3,700 litres.

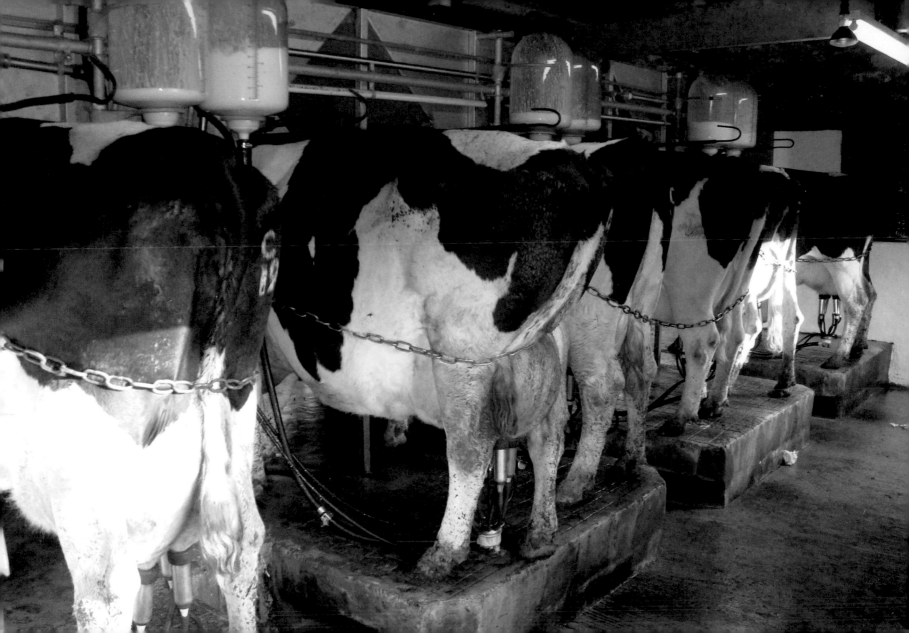

Farming can be full of surprises and this field of poppies is no exception. There hadn't been poppies in this field for years, but when it was ploughed up some old seed must have been disturbed as this display suddenly sprang up.

In our continuing efforts to care for the wildlife on the farm, we have worked with the Avon Hawk and Owl Trust to place owl boxes around the farm. My father and I have also made a couple of barn owl boxes from old scaffolding planks which we placed in an isolated barn. Barn owls were once a common sight on farms, but changing farming practices and the use of DDT spray meant that their numbers rapidly declined in the mid-twentieth century. The numbers of this bird are thankfully now recovering and it's important to give them the best opportunities possible. The varying habitats on our farm, along with these nesting boxes, provide barn owls with ideal conditions and luckily a few years ago we spotted the first barn owl on our farm in forty years. Since then, we have had a breeding pair that has produced two chicks, which caused great excitement.

While these birds are shy and hard to see in daylight, they do leave a very distinctive trace in the form of owl pellets. These pellets are the regurgitated remains of the barn owls' last meal, and contain the bones and fur of the small rodents they eat.

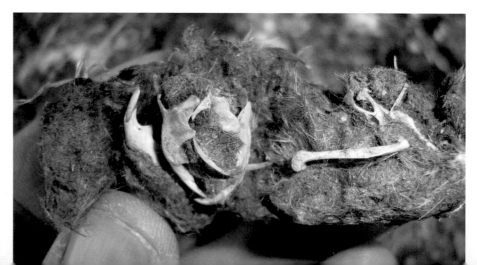

JULY

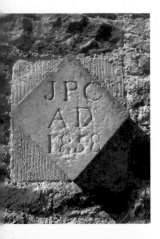

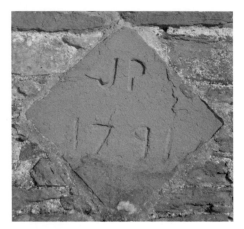

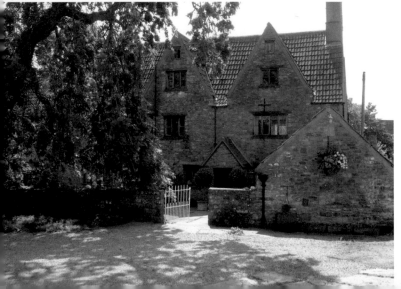

Like most farms, the farmhouse is the heart of the enterprise; not only is it a home, but it also doubles as an office, canteen, veterinary surgery, and a whole host of other roles.

The house at New House Farm dates from the early 1600s, although it is believed to have been built on earlier medieval foundations. Consisting of three floors with outhouses and a well, the house has seen many changes of use and layout over the years. Originally, the house was used in the Cotswold woollen industry and weaving is believed to have been carried out in the large attic rooms. On the ground floor, two large inglenook fireplaces are situated at either end of the house, and one has bread ovens built into its walls as well as a smoking chamber where hams were cured. During the eighteenth century, many of the house windows were blocked in when window tax was introduced. These windows were only reopened in the 1970s and 80s. During this time, my parents undertook a long and painstaking restoration of the house. Due to its age, much of the structure had become rotten and unstable, while death-watch beetle and wood worm had ravaged the internal timbers. In some places you had to tread carefully to avoid falling through the floor, and some of the large internal beams that supported the ceilings had been eaten away until only a small sliver of wood kept the whole lot from crashing down. With the help of local builders and the use of oak and elm timber grown on the farm, it has been possible to lovingly restore the house and not only repair the damage of time, but also put right the unsympathetic additions made by some previous generations.

Outside the house, my mother has spent many hours transforming what was a large potato patch into a tranquil oasis of lawns, flower borders, and vegetable patches.

Around the farmyard are reminders of previous occupiers of the farm; the initials of James Pullen and James Pullen Cornock are inscribed onto two of the buildings.

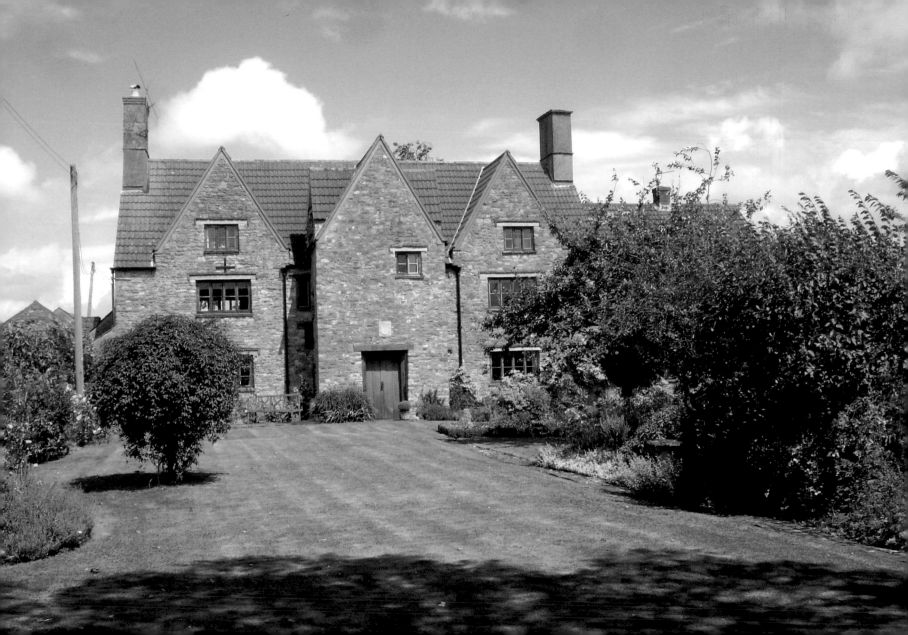

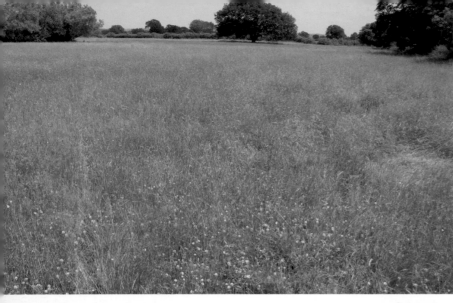

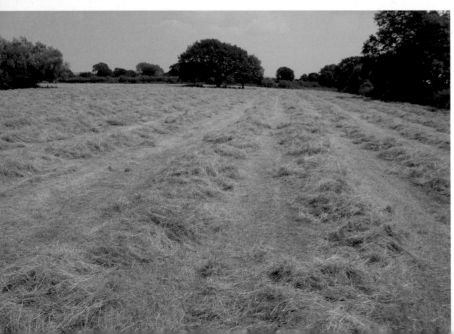

Haymaking has largely gone out of favour in today's farming as it's a time-consuming method of making forage. A week's worth of good weather is needed to dry the hay and a downpour of rain at the wrong time could ruin the crop. Because of this, silage (see May chapter) has largely replaced haymaking as it is not only a lower-risk method of conserving grass, it is also quicker and less labour-intensive.

However, as part of our environmental scheme for the farm, we still make a couple of fields of hay. These fields are semi-improved grassland, containing a number of interesting wild flowers such as greater burnet, purple vetch and knap weed (pictured overleaf).

By not mowing the grass until mid-July, the wild flowers in these meadows have time to seed; the haymaking process spreads the flower seeds around the meadows and helps to increase the wild flower population. Once the grass is mown, it is then spread out to dry and turned once or possibly twice a day to expose it to as much sunlight as possible. Turning the grass speeds up the drying process and hopefully allows the crop to be baled before a possible rain shower ruins the quality of the hay.

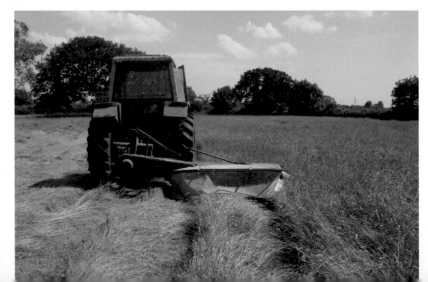

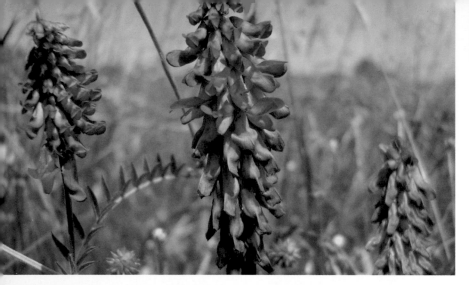

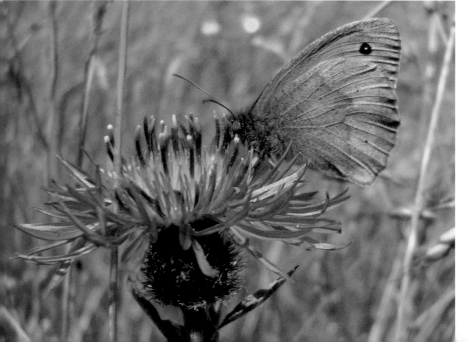

It is important that the hay is dry enough to bale as if there is too much moisture still contained in the grass it will go mouldy during storage and be no good as cattle feed. It is a matter of practice to judge whether the hay is fit enough for baling; sometimes a gamble is needed on when to call in the baler when the weather is unsettled.

The baler is a clever machine that first rakes up the hay then compresses it into oblong bales. At the same time it splits the bale into sections (so that it can be easily separated when later needed for feeding) as well as tying string around the bale to hold it together. When finished, the completed bale is deposited into the sledge that trails behind. Once full, the sledge drops the bales in neat groups of eight ready to be collected and loaded onto a trailer.

Making hay can be time-consuming and sometimes difficult, but there is something special about 'a bit of hay'. In my mind the sweet aroma of the grass is very indicative of summer and reminds me of the fun we had as children larking about in the hay.

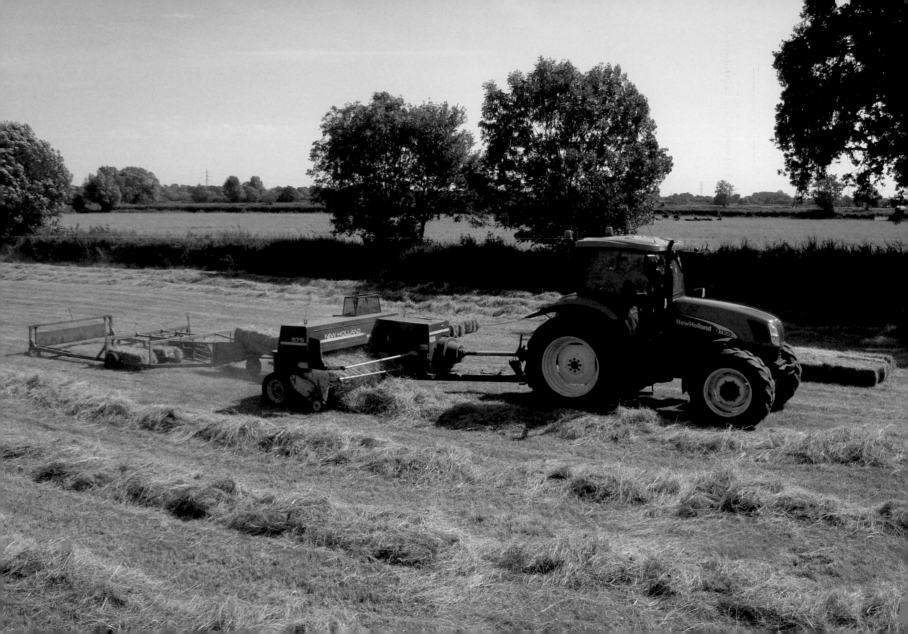

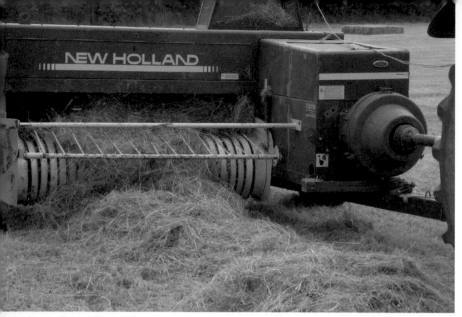

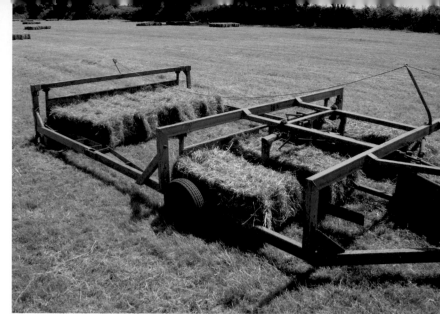

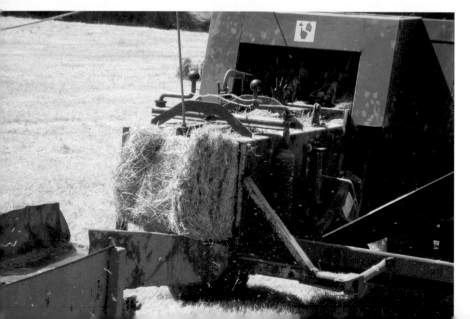

Once the baler has finished its task, it is time to collect up the hay and take it back to the hay barn at the farm. This is usually a two-man job and involves either my brother or myself using a flat eight loader on the tractor to pick up the bales and deposit them on the trailer. Whoever isn't driving the tractor gets the job of ensuring all the bales on the trailer are positioned so they don't fall off during transit. This can be hot hard work and it's always a good idea to have a dollop of suntan lotion and a bottle of squash handy when loading hay.

Luckily we can get to the barns at the farm without having to go onto the road, otherwise we would have to improve our stacking skills and also rope down the bales on the trailers. Once at the farmyard, we unload the bales by hand in the evening when it's cooler while the young cattle are let into the empty hay field to pick up any grass the mower or baler has missed.

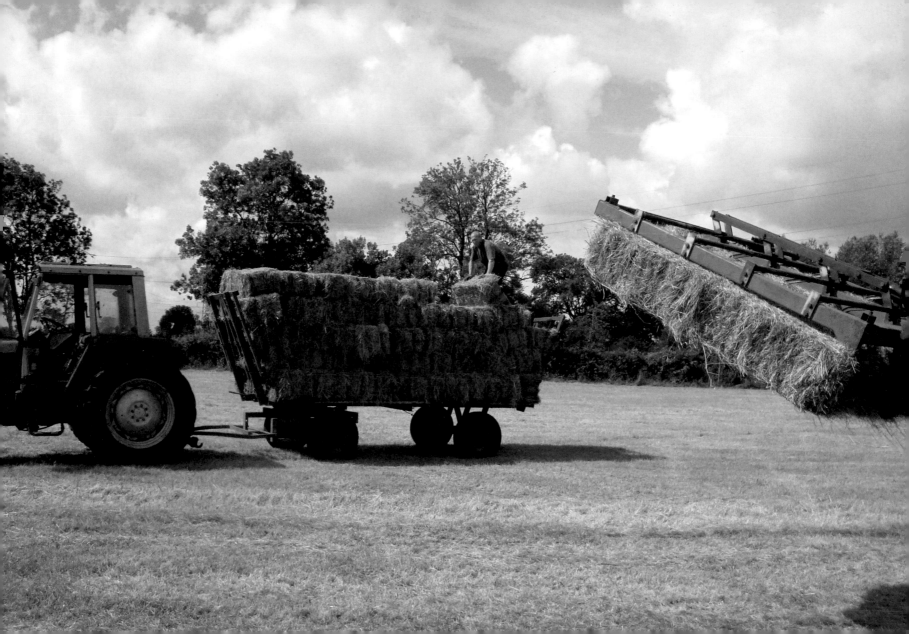

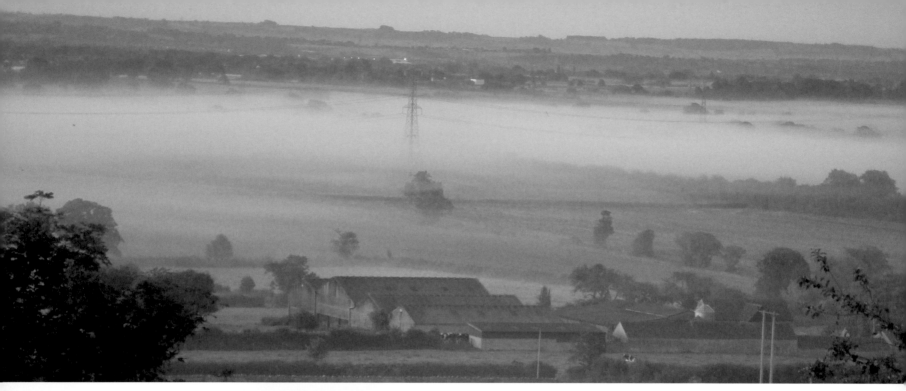

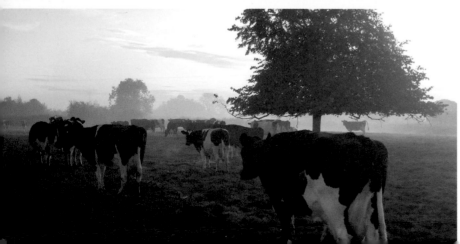

Something a lot of people miss out on is the wonderful freshness of early mornings in the countryside. A lot of people would still have been in bed when these photos were taken just before 6 a.m. Cool ground temperatures in the summer months can lead to early morning mists; this can make it interesting when getting the cows in for milking as they play a game of cow hide-and-seek with you in the swirling mist. Sometimes, just when you think you have all the cows rounded up for milking, a few more will appear to join the herd.

Combined with the gentle glow of sunrise, these mornings do make up for losing the odd hour's sleep.

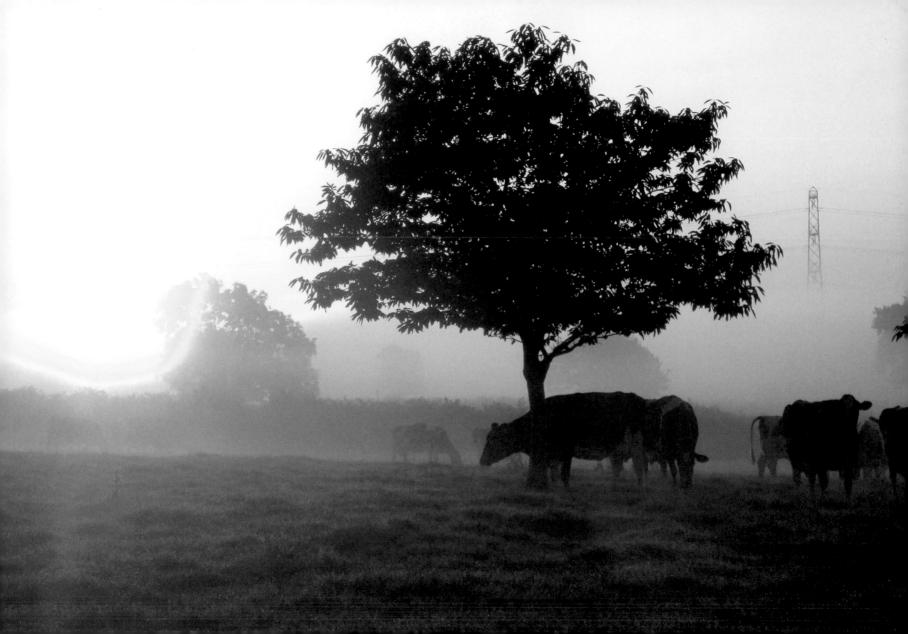

AUGUST

During August there is a feeling that autumn is approaching as the maize plants produce their cobs and the various fruits in the hedges start to ripen. In many ways, the picture of the dandelion reflects this passing of time as the seeds float away on the wind ready to start the cycle of growth again.

The flowering of the red clover in a new ley of grass makes an interesting splash of colour at this time of year. This new ley was deliberately planted with a high percentage of clover seeds as clover helps to fix nitrogen in the soil, which increases soil fertility and reduces the need for artificial fertilizer. Artificial fertilizer requires large amounts of energy in its production; as a result, fertilizer prices have risen considerably in the last few years. Together with concerns about greenhouse gases, it has meant that more and more farms are looking at alternative means to improve soil fertility, such as growing clover, crop rotation, and green manuring.

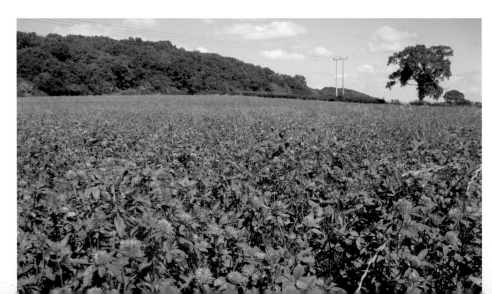

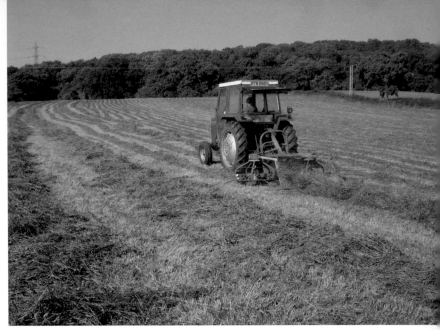

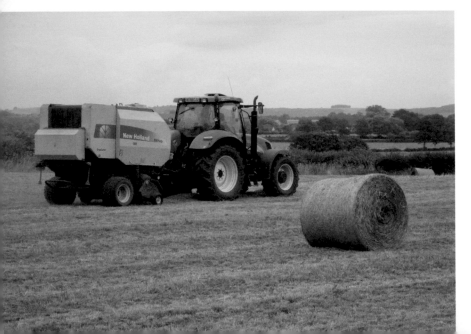

During the summer, we make several hundred round bales of silage which will be used in the winter to feed the cattle. This is a very convenient way of making forage as the silage bales are quick to produce and easy to transport and store.

My brother or I will mow the field about 24 hours before it is due to be baled to allow the grass time to wilt so that the silage is not too wet and has the desired feeding quality. About an hour before baling, the grass is 'rowed up'. This is a relatively simple job of putting two rows of grass into one to reduce the amount of travelling the baler has to do to get enough grass to make a bale. Once the contractor arrives, it doesn't take long for the whole field to be baled and made ready for the wrapping machine. Before wrapping, each bale is encased in a clear plastic mesh to retain its shape.

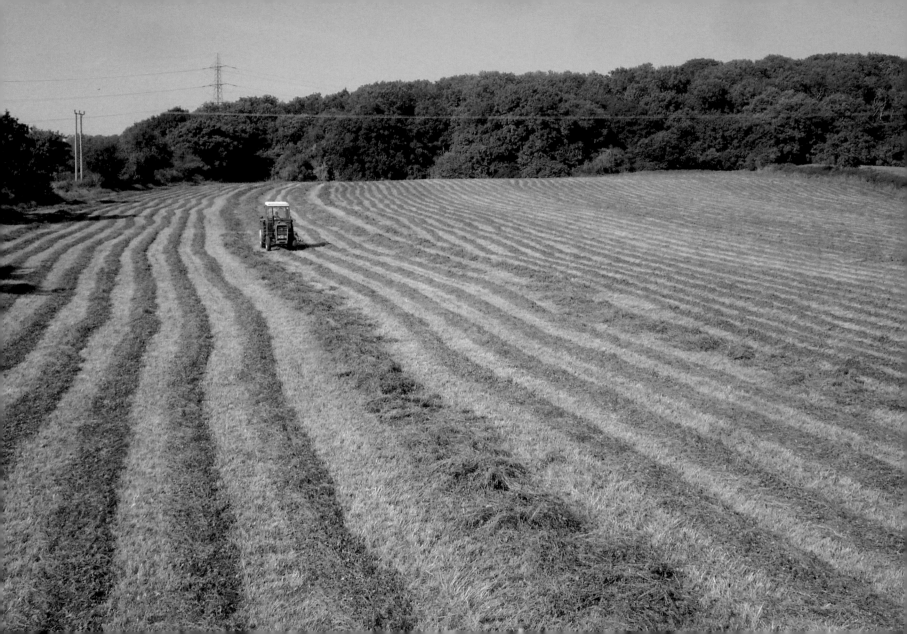

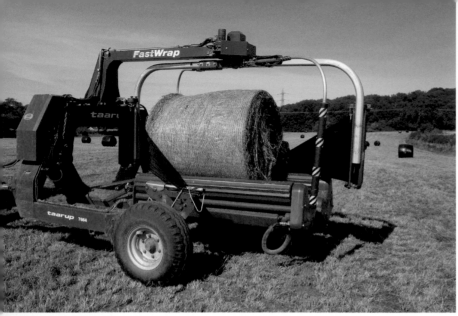

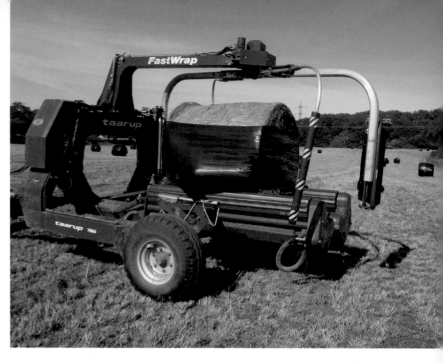

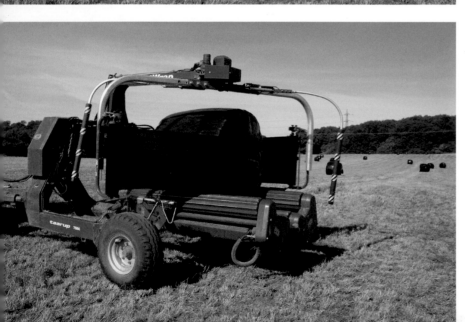

Once the baler has finished, the wrapping machine usually arrives within an hour or so. This machine is quite a sight to watch in action. It is driven into position, straddling the bale to be wrapped; it then picks the bale up off the ground and rotates it while two arms holding rolls of plastic film spin around the bale, wrapping layers of plastic around its entire surface. When finished, the whole of the bale will be covered in two to three layers of film, forming an air tight barrier that preserves the contents and protects it from the elements. These bales can then be left in the field to be collected when time permits, but leaving them there too long can result in crows pecking holes in the tops of the bales and the grass under them dying off. For this reason we aim to move the bales from the field within a week of wrapping.

Once the bales have been wrapped, my brother and I collect them using the same trailers that we used to haul the hay a month earlier. We use a grab mounted on the tractor loader that uses two rollers to pinch the bales so we can pick them up without making any holes in the wrapping. That is the theory anyway; in reality we always have a few rolls of tape with us when moving bales as invariably one or more of them will get punctured and need some remedial work on the wrapping. Once we have loaded the bales onto trailers, it's just a short drive to an area of hard standing where we store the bales until winter when they are needed.

Compared with making a field of hay, this process is very simple and efficient. The time and effort needed to make this forage and the chances of it getting spoiled by rain are greatly reduced, so it's easy to see why haymaking has largely gone out of fashion.

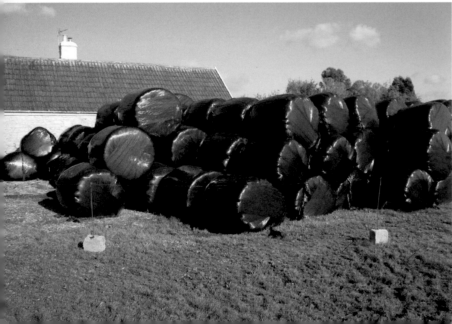

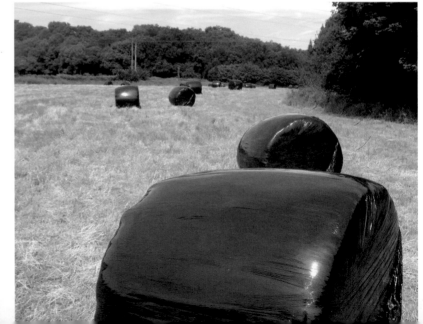

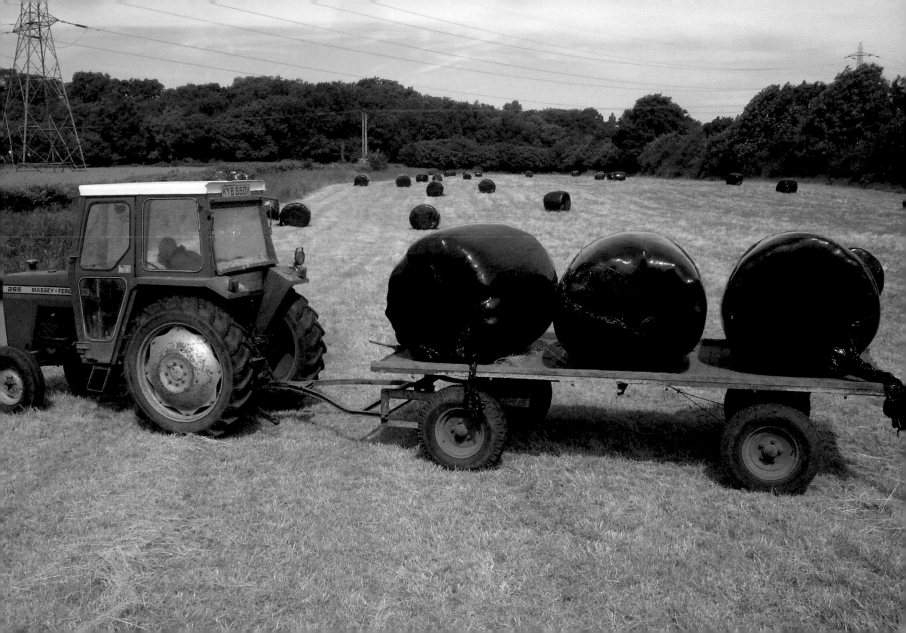

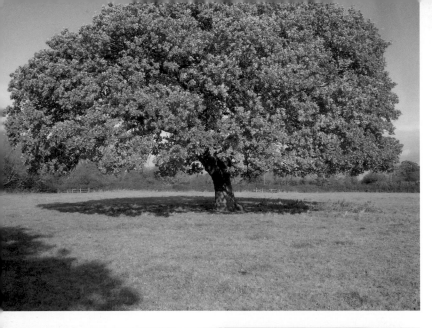

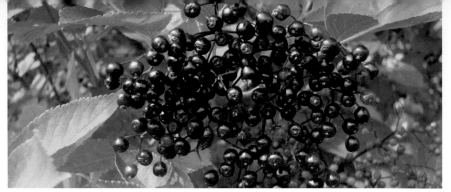

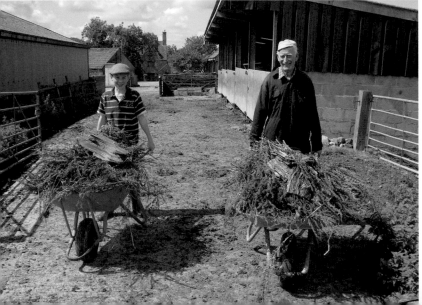

By the end of August, the pace of life on the farm relaxes as the silage has been safely baled and the maize has yet to be harvested. At this time of year, my nephews enjoy helping out on the farm for some of their summer holidays. Pictured here is my nephew Thomas Harris helping to wheelbarrow docks to a fire ready for burning. Docks are a nuisance plant to farmers as they have no feed value and can spread rapidly. The choice is either to spray them or hand pull them. In this case my father has pulled a large clump from the silage fields.

Meanwhile, around the hedgerows the elderberries are starting to ripen and form large clumps of dark juicy fruits that the birds love to eat. The large oak tree in the hay meadow is also at its finest with a wonderful canopy of leaves. By measuring the circumference of the trunk, I have been able to calculate that this tree is about 180 years old; it would have started life just twenty-five years after the battle of Trafalgar and seven years before Queen Victoria was crowned. On several farm walks that I have organised, I have asked people to hug this tree and to guess its age; usually people are years out, despite a prize of a bar of chocolate for whoever gets it right.

Graham the ferreter is a regular visitor to the farm throughout the year. With his pair of ferrets and nets carefully placed over rabbit holes, he manages to keep the rabbit population under control. Without his help they would breed quite literally 'like rabbits', and cause considerable damage to the grass. The rabbits he catches usually end up in the window of the local butcher's.

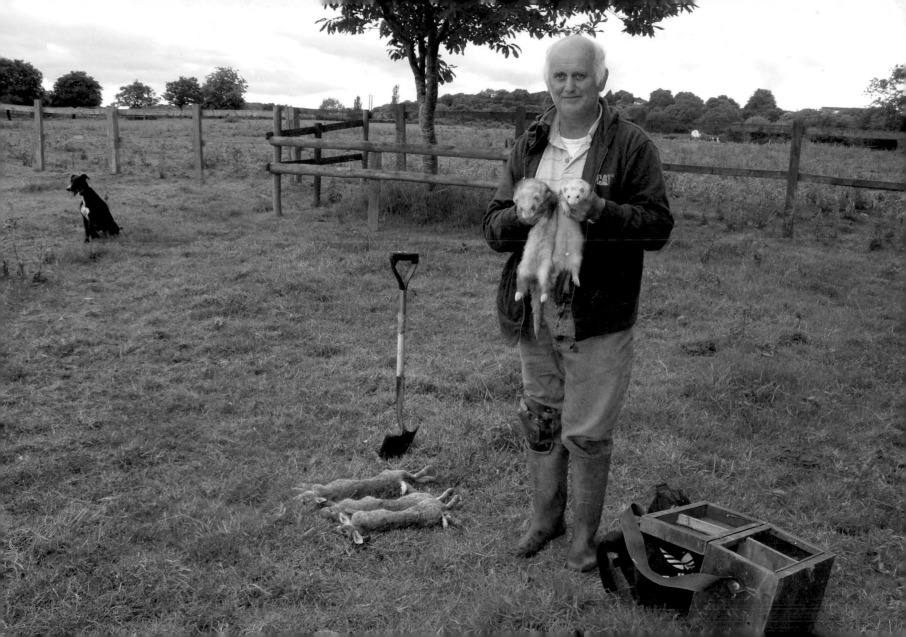

SEPTEMBER

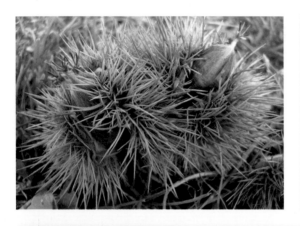

September days can be long and mellow with the tinges of autumn just starting to show through. The cows continue to enjoy the warm weather in the fields, seemingly unaware that change is just around the corner.

A wide variety of seeds and nuts can be seen on the trees around the farm. The oaks have a covering of acorns while the horse chestnuts provide plenty of opportunities for my nephews to play 'conkers', and I must admit that I still get delight from opening a fresh seed pod to reveal the new shiny conkers inside.

The sweet chestnut also drops nuts at this time of year, covering the ground under the tree with masses of spiky pods. Once prised open (mind your fingers), these reveal the chestnuts that are traditionally roasted on an open fire at Christmas.

On the farm we have several walnut trees planted by my father. These produce a ready supply of walnuts and at this time of year it is a race between my father and the local squirrel population as to who will get the best nuts first. Once picked, these nuts will go into the farm house attic, ready for winter consumption.

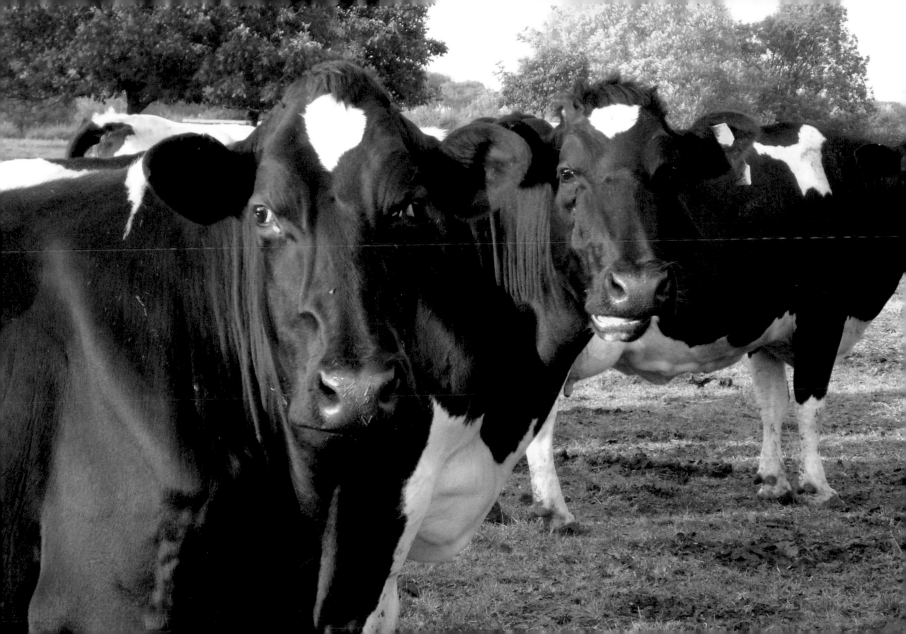

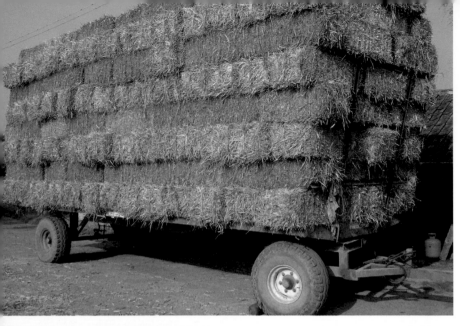

At this time of year the sun starts to rise a little later and there is a nip in the air when getting the cows in for morning milking. It's time to start wearing a jumper for at least part of the day and to start thinking of the forthcoming autumn and winter.

In preparation for housing the cattle in the winter, we take delivery of the straw needed for bedding the cows down in their cubicles. This is bought from a local farmer who delivers it to us in loads freshly baled from fields that have just been combined. We buy in over 1,000 small bales of wheat straw for bedding, plus a quantity of barley or oat straw which can either be used as bedding or, should the hay run out, for feeding to young calves. The bales are stacked in the barn and bags of bait are placed between them to control the rats and mice that would otherwise have a field day in the straw and eat their way through the stack. Hopefully these loads of straw will see us through the winter months.

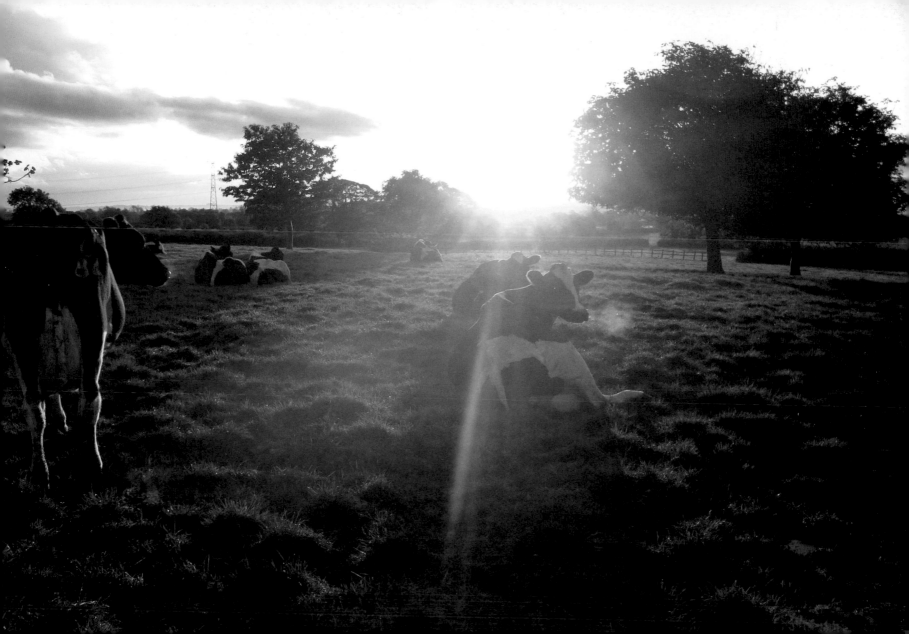

Throughout September the ripe seeds and fruits of the hedgerow offer birds, animals, and humans a chance to enjoy nature's harvest. Rose hips and hawthorn berries make a stunning red display in the hedgerows that many birds will feed on over the coming months. Large clumps of blackberries offer the chance of a quick snack when getting the cows in, or an evening of blackberrying for my nephews. The blackberries they pick will be turned into jam or made into blackberry and apple pie with apples from the orchard. The snowy white spring flowers of the blackthorn have by now turned into dark tempting fruits called sloes. These look very appealing with a dark purple colour that makes them resemble grapes. However, one bite will leave you with a screwed-up face as their bitterness is intense. Luckily, when put into a bottle of gin with a little added sugar, they make an excellent Christmas drink in the form of sloe gin.

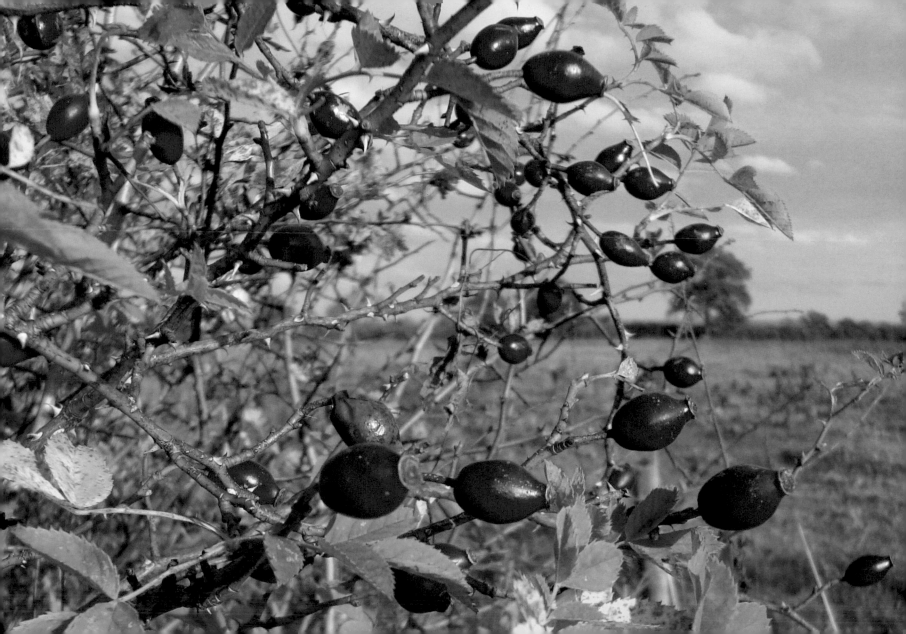

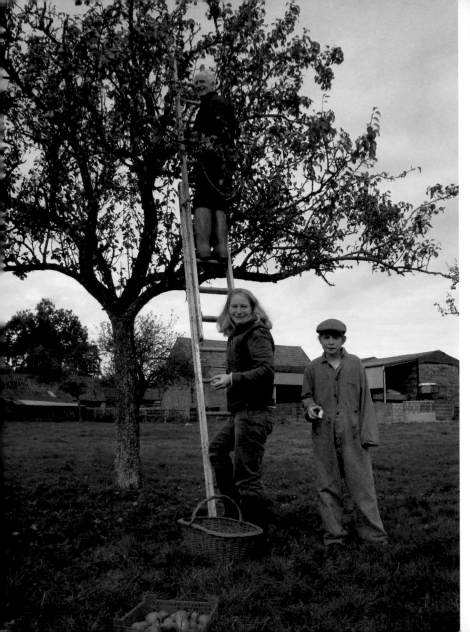

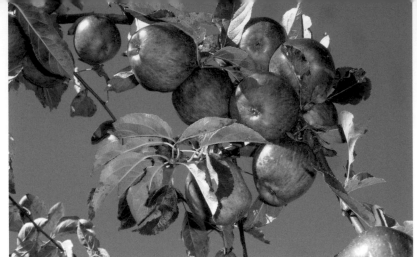

One of the highlights of the autumn harvest has to be the ripening of the fruit in the orchard. It's at this time of year that you really appreciate having an orchard. The trees are laden with fruit and there is nothing better than picking a ripe apple straight off the tree when it is still covered in the early morning dew and biting into its sweet firm flesh. The orchard is full of old varieties, but my two favourites are the Jupiter apple and the Conference pear (both pictured). We pick the fruits by hand to avoid bruising and store them in the attic of the house along with the walnuts for use over the winter. It's a tricky job picking the fruit as with these large standard trees you need a few helpers to hold the ladder firm and to catch the fruit. At the same time it's important to avoid bruising the fruit as this will reduce its keeping time. Modern orchards have gone for smaller trees that can be reached more easily and harvested mechanically; however, our taller trees are better suited for allowing cattle to graze under them without reaching the branches and eating the fruit. In this picture my sister Janine and my nephew Tom are helping my father pick Conference pears.

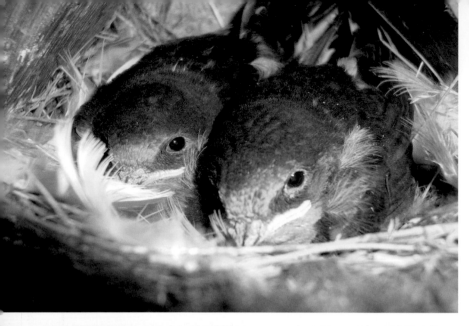

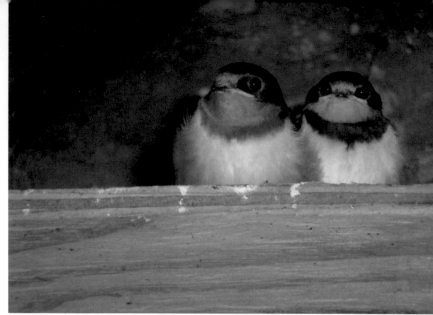

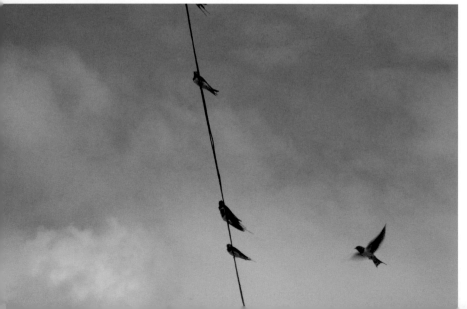

In early April every year, regular as clockwork, swallows arrive back at the farm after spending the winter months in Africa. These swallows nest in various sites around the farm, but one of their favourite places is the porch of the house above the back door. The nests are made up of moss, mud, and straw from around the farmyard, and it's fascinating to watch how they take mud from a puddle in the yard and slowly build up layer upon layer until they have built a good solid nest.

Over the summer, they usually have three to four broods of chicks, and spend most of their time flying in and out of the doorway with incredible accuracy as they feed their chicks. This picture of swallow chicks was taken in September and shows a very late brood. Already at this time of year the swallows have started to gather on the power lines in the farmyard which is always a sign that they are preparing to head south, back towards Africa for the winter.

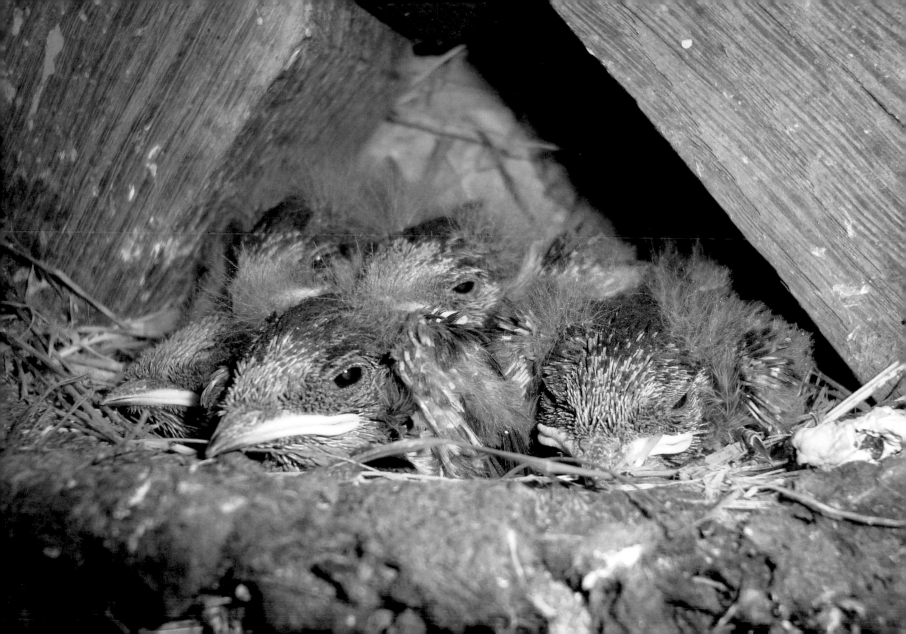

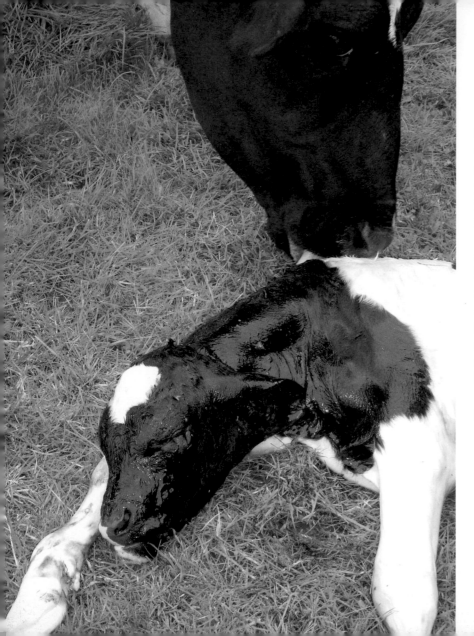

OCTOBER

October brings the final flourish of fine weather before winter, and with it the sense that you really should make the most of the last warm days. The cooler days and reduction in sunlight hours at this time of year mean that the growth rate of the grass in the fields slows and lacks the feed quality of grass earlier in the year; it's time to open the silage clamp and give the cows some extra feed.

Calving on our farm takes place throughout the year, and at any one time there is usually a calf about to be born or a new arrival to be looked after. A month or so before calving, the cow is dried off, which means they are no longer milked and are allowed to rest in a paddock. As the due date approaches, we watch the cow at regular intervals to ensure she is okay. Once calving begins, most of the time it's just a case of standing back and letting nature take its course. However, occasionally we have to intervene if, for example, the calf is coming backwards or has a leg in an awkward position.

Once the calf is born it doesn't take long for it to find its wobbly feet and head towards mother for a long suck of fresh milk.

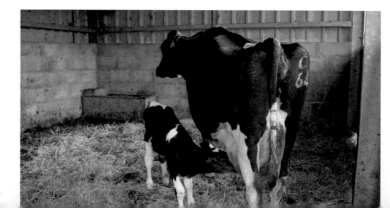

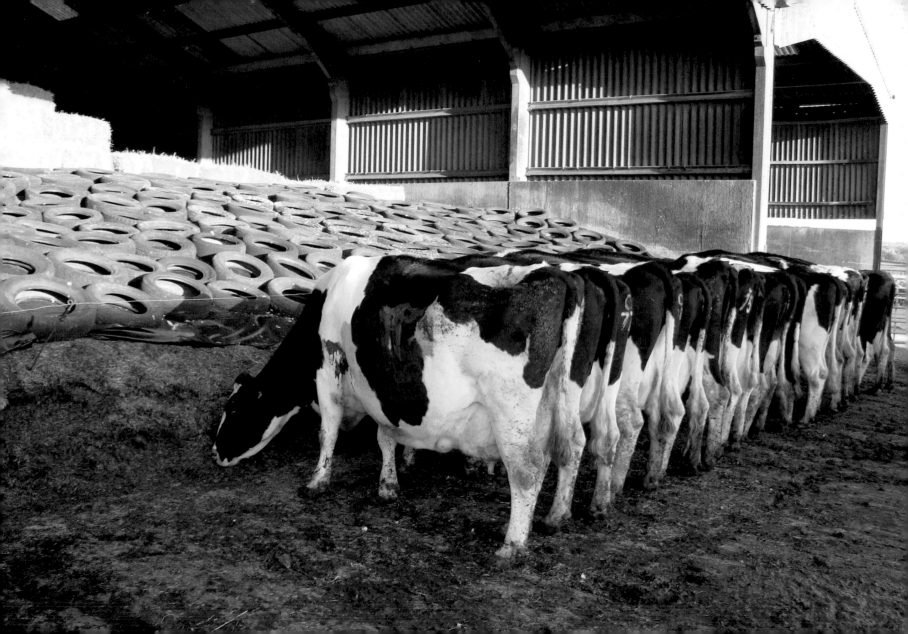

To get the cows in calf we use A. I. (artificial insemination). This gives us the flexibility to choose which breed or type of calf the cow will produce. An A. I. man from a company called Genus is available on call and comes to the farm whenever a cow is ready to serve. He brings with him a flask of frozen bull semen which is packaged in individual straws; the straws are defrosted and used to serve the cow using a long thin insemination rod.

We generally choose for the older cows to have British Friesian calves; the female offspring are reared as replacements for the herd. These calves are taken off the cow at about two weeks old and placed in pens where they are fed a diet of milk and calf feed until they are old enough to be weaned. At this stage they are then put into larger sheds where they are reared until an age when they can be let out to grass.

For the younger, immature cows (heifers), we choose the Aberdeen Angus breed as these calves are easier to give birth to and so cause less stress at calving. These calves will be reared for beef and we sell them at three to four weeks old, either to a local calf rearer, or at Sedgemoor market. The male Friesian calves are also sent to this market.

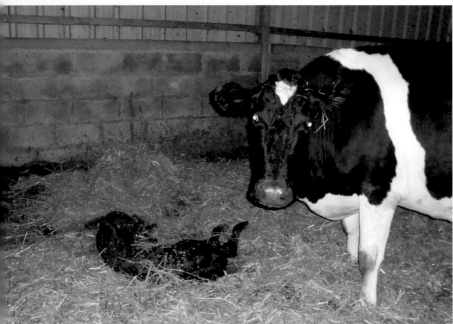

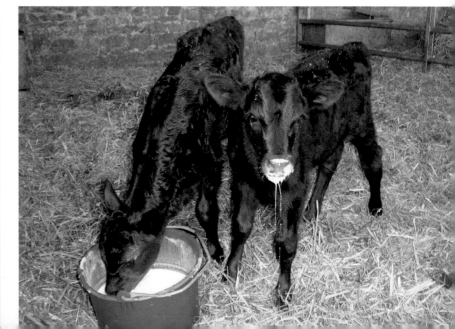

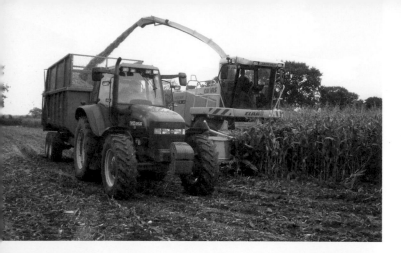

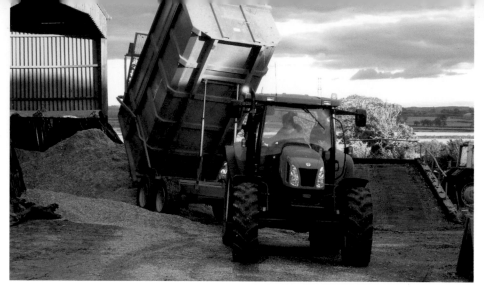

October is the time of year when the maize is harvested. The corn cobs on the plant are checked regularly for ripeness and when the kernels are no longer milky when squeezed it is time to call in the contractor again. Making maize silage is very similar to grass silage except the crop is cut and taken to the clamp in one operation rather than being left to wilt for a day. The whole of the plant is harvested but the cobs provide the main energy in the silage. The maize plants are cut and chopped by the forager and the kernels are cracked to allow the contents to ferment. It's quite a sight to watch the forager in action as it devours the maize plants leaving behind only stick-like stubble and a few missed cobs for the crows to pick over. The harvested maize is transported to the farm by a team of tractors and trailers where it is stored ready for feeding over the winter. At the end of harvesting, the maize will have been rolled and compressed in the clamp and it just remains for us to put on the cover sheet before sealing it and weighing it down with straw bales to make the clamp air tight. When the last of the maize is in the clamp, you do get a sense that summer is over as this is the last harvest of the year and the last time the contractors will be on the farm until next spring.

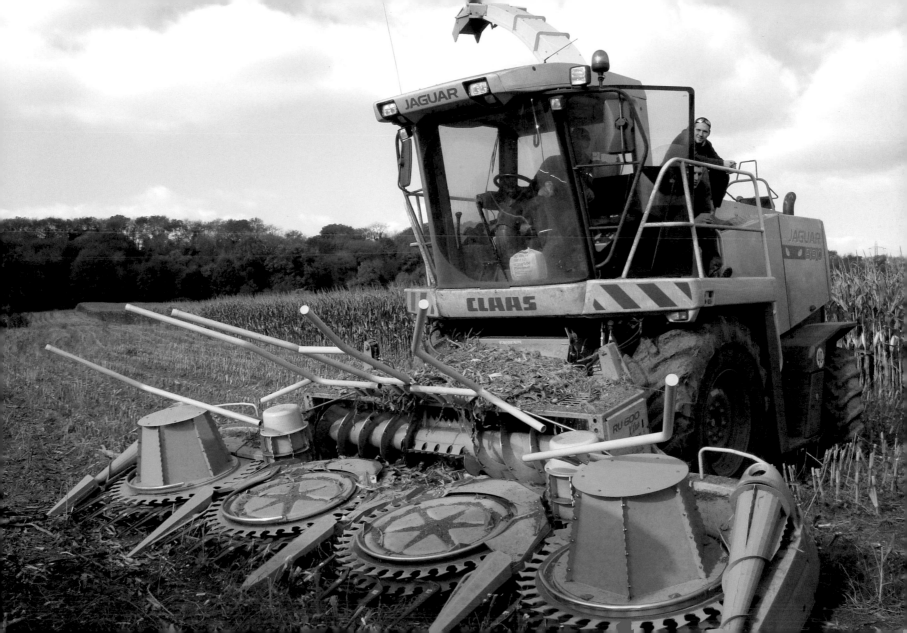

From spring to autumn the farm displays an array of colours as flowers bloom and fruits ripen. One of the most colourful aspects of the autumn has to be the changing colours of the leaves before they fall. In particular, the field maples that line the lane going down to the hay meadows turn a beautiful golden colour. At this time of year the clear blue skies and crisp fresh air make walking the footpath down this lane a very pleasant experience as the leaves form a golden canopy above your head. Elsewhere the oak, ash and lime trees all drop their leaves and cover the surrounding ground with a carpet of colours. Near the farmhouse the gutters and flagstone courtyard have to be cleared of leaves as the large weeping ash sheds its summer coat.

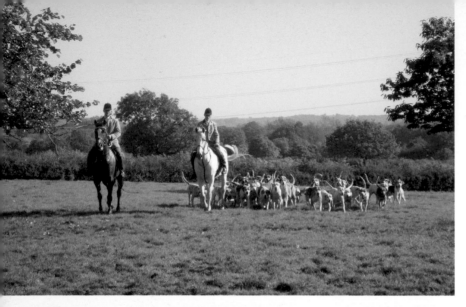

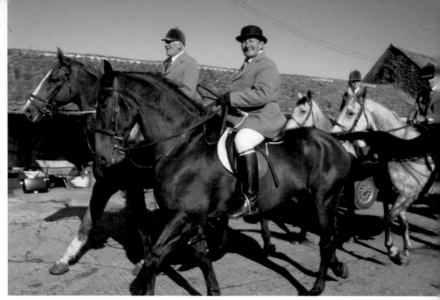

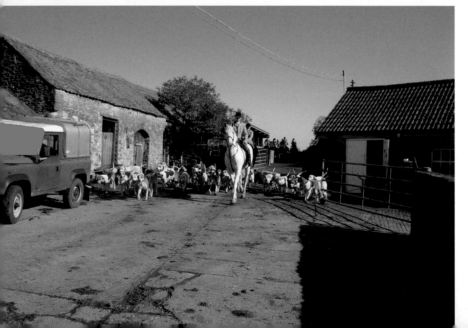

As autumn turns to winter, the local Berkeley Hunt starts the hunting season after a summer lay-off. Since the eighteenth century, the Berkeley Hunt has kept hounds to hunt foxes and has roamed freely across many fields and farms of Gloucestershire. In more recent times, this practice has been the subject of some controversy and in 2005 the hunting of foxes by hounds was outlawed. Since then the Berkeley Hunt has continued to visit farms in the county, but no longer chases a live quarry. It now follows a scent laid down by a member of the Hunt; this is known as drag hunting. The Hunt has a keen group of followers that watch its progress throughout the day.

The Hunt also provides a service to our farm by taking away occasional dead stock which it then uses to feed the hounds. Unfortunately, there will always be the occasional animal fatality and as the law no longer permits the burial of animal carcasses on farms, this service provided by the hunt is a convenient answer to the problem of disposal.

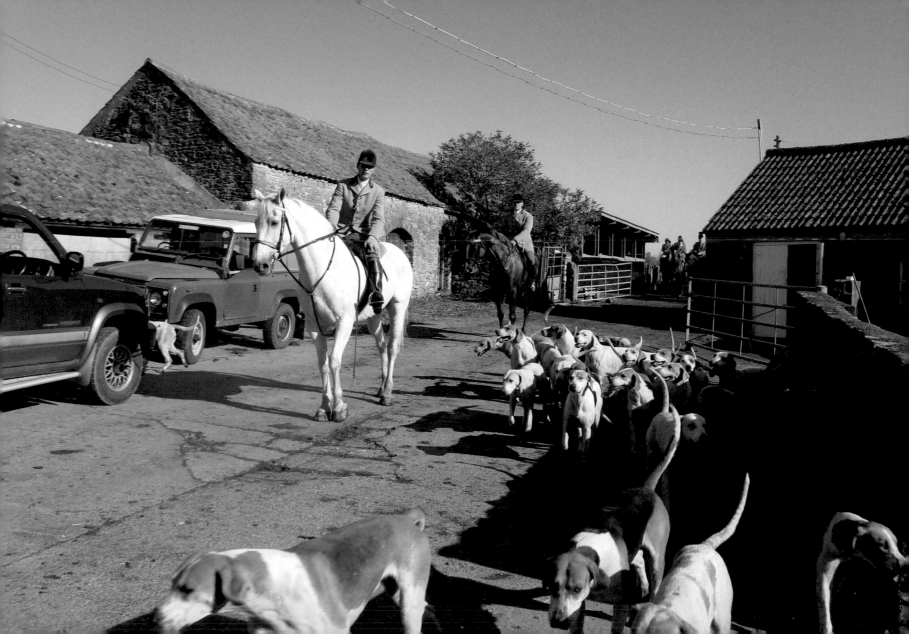

NOVEMBER

In November the round bale silage we made in the summer is ready to feed to the cattle. We transport bales daily to the cattle already in sheds and to the dairy herd which will soon be inside too.

By mid-November the dairy herd is kept inside both day and night. We keep the cows out to grass for as long as possible but there comes a point where there is little grass for them to graze and they start to churn the ground up with their feet; at this point the decision is made to shut the field gate for the winter. In many ways, keeping the cows in signals the start of winter to me as it means the start of a continuous routine of milking, feeding, and cleaning out for the next six months.

In these pictures of the cows you can see yellow tags in their ears. Printed on the tags is our herd number plus a unique identity number for that particular animal. Each cow also has a passport that corresponds with the numbers on these tags. Without this passport and correct corresponding ear tags it is impossible to sell the animal.

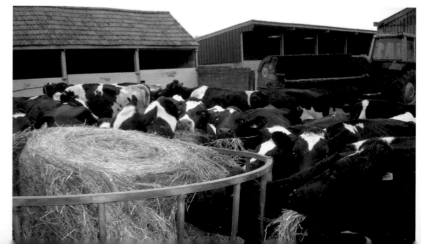

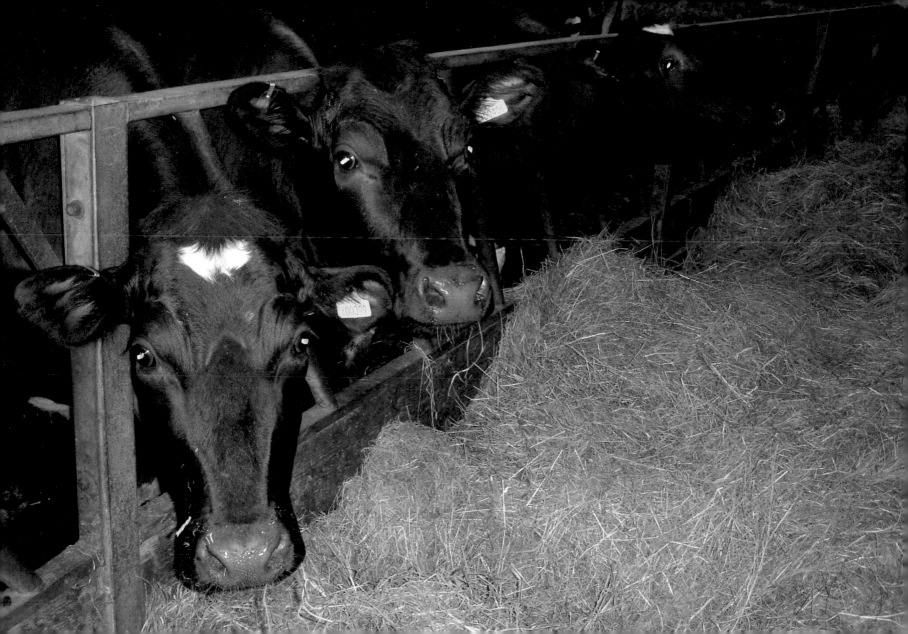

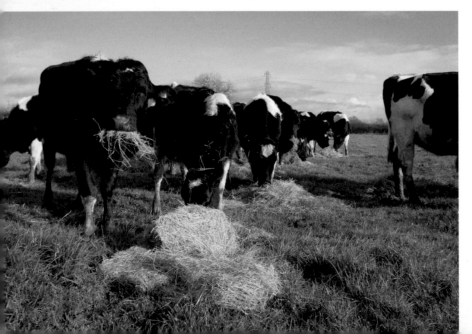

Once the cows are inside it is only the young stock that are left in the fields. These cattle are allowed to roam the fields extensively to avoid damage to the ground, and because they are not producing milk and require less grass than the dairy cows. We also give them some extra feed to supplement the lack of fresh grass in the fields. This is where the hay made in the summer comes in handy; we put two or three bales of hay in the back of the Land Rover and take it to them daily. When you arrive in the field with the hay the cattle know you are bringing them food and will rush towards you. It's important to be quick when putting the hay out as otherwise they could knock you over in their eagerness to be first there. The photo opposite shows a view from the farmhouse looking down to the fields where these cattle graze. As you can see from the photograph, the lowest fields are flooded and so these young cattle are only kept out for a few weeks longer than the dairy herd before they too are brought inside for the winter.

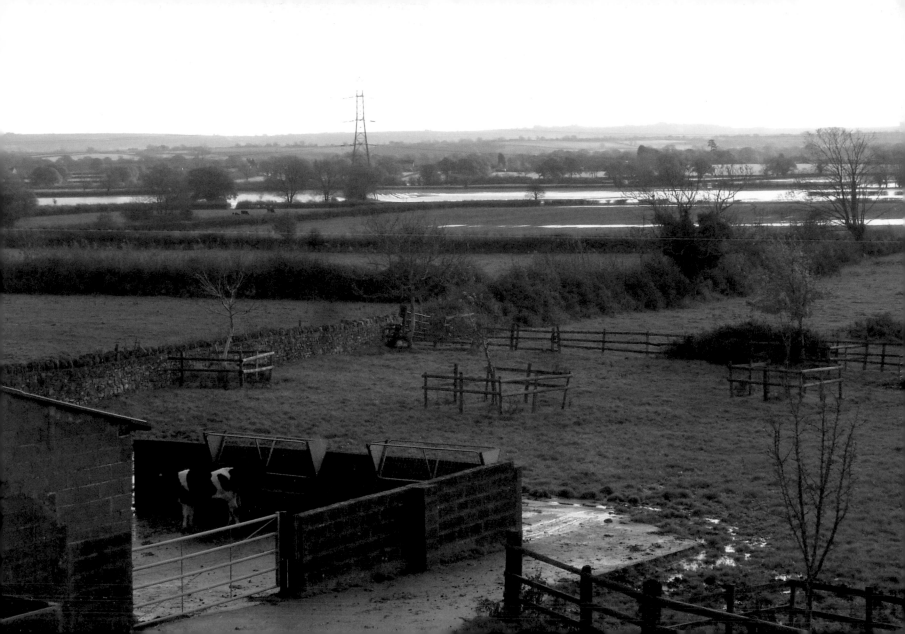

The onset of winter brings a significant change in weather with an increase in heavy rainfall. The farm is situated on a slope with the farmhouse and buildings at the top of this gradient and the fields sloping away until they level out where the hay meadows are. The hay meadows are at the lowest point of the farm and have a small stream flowing through them called the Ladden Brook. Whenever there is prolonged heavy rain this brook is unable to cope with the amount of water it has to carry and bursts its banks, flooding the surrounding fields. The flood water is usually about a foot deep over the fields and will only stay for a day or two after the rain stops. During the flood, flocks of seagulls use the hay meadows as a lake and it can be quite strange to see them swimming about on the water with the grass showing through underneath. When there is a sharp frost, the top of this water can freeze and transform the whole field into a sheet of ice.

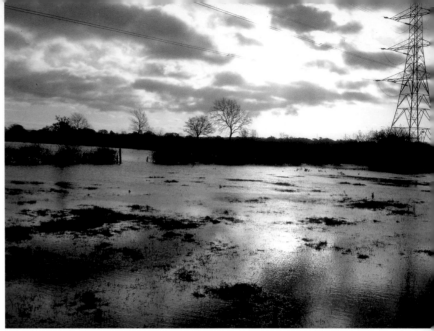

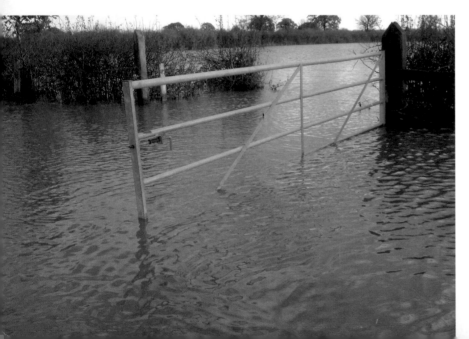

This flood water doesn't cause any real problems in the winter as by the time these fields have flooded the cattle are no longer in them. However, occasionally when we have had really wet summers these fields have flooded and washed away crops of hay or temporarily marooned cattle on small islands of grass.

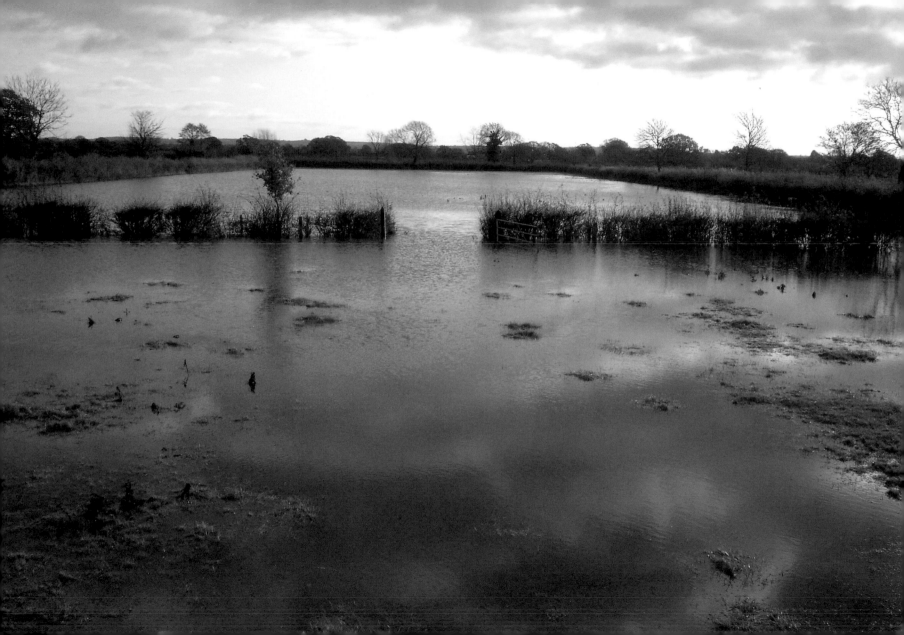

Along with the winter rain comes strong winds. On a windy night, the damage you might find in the morning crosses your mind many times. Often it will be a row of roof tiles blown off, but occasionally the damage will be more significant and some of the older trees on the farm will blow over. The pictured tree is an ancient willow that, along with a dead sycamore, came down on a particularly gusty night. The wood from the sycamore was sawn into lengths and stacked to dry out before being sawn for logs. The willow, however, was left where it fell as the wood in its trunk was quite rotten and not very good for logs. The decaying wood has provided a valuable habitat for fungi, insects, and beetles. The loss of this mature tree shows the importance of allowing new saplings to grow on the farm so that there are replacement trees to take its place. Without these new trees, the hedgerows and fields would slowly become featureless.

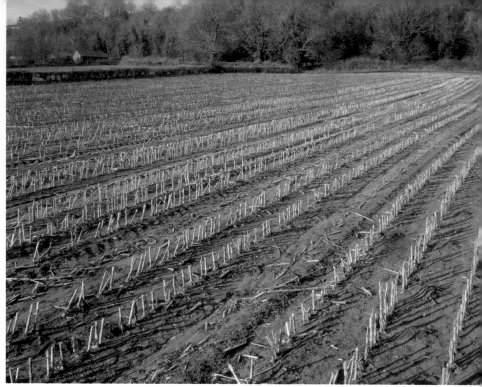

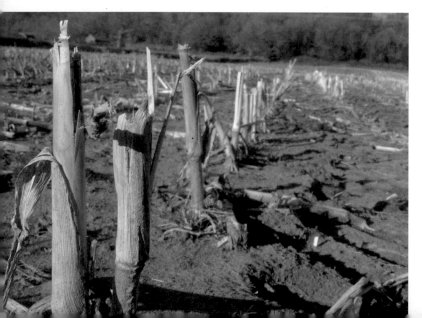

By this time of year the maize fields look very bare with just the stems of the harvested maize plants standing like rows of broken teeth above the ground. The most important part of the maize plant is the cob which provides most of the energy in the silage; for this reason the plant is harvested quite high off the ground (about 20 cm) as these stems provide hardly any nutrition. The remaining stems are very tough and take a long time to rot down. In the spring they will be ploughed into the soil when the field is being prepared for replanting.

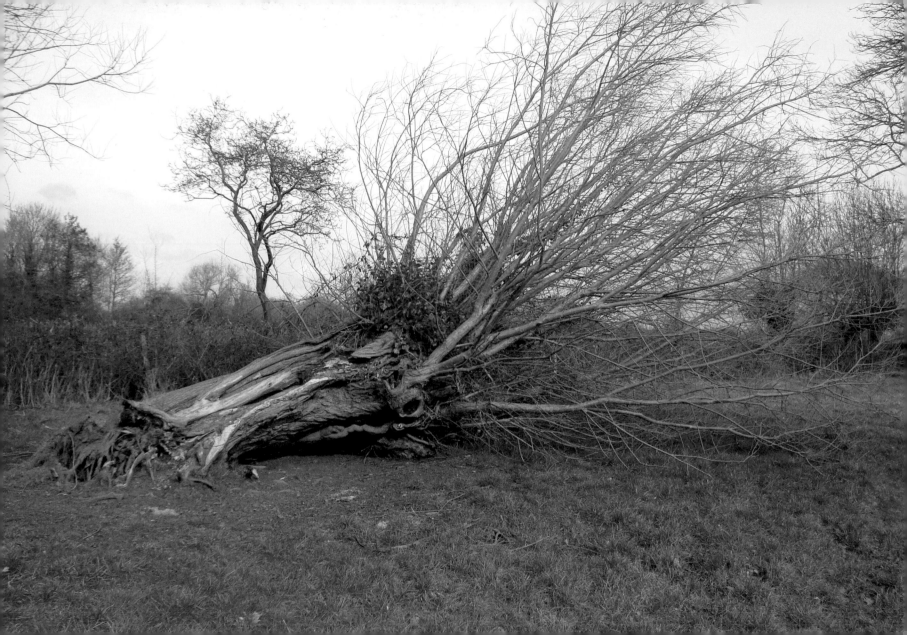

DECEMBER

During the winter a wood burning stove is used to heat the living room of the farmhouse. This requires a constant supply of logs which are supplied by the farm. Wood from fallen trees, pollarded willows, and even old fence posts, are stacked and left to dry until we have a spare morning to saw the lengths of wood into logs. The saw bench we use for this is fitted to a Massey Ferguson TE20 tractor which was bought new in 1956 by my father. In its day this tractor was an advanced piece of machinery, but now it looks quite quaint compared with the large 4 x 4 tractors that are used on many farms today. Sawing the logs can be quite dangerous with the large saw blade whizzing round at speed; great care has to be taken when using this machine. Since these photos were taken, extra guarding has been fitted to the saw bench.

Once the logs are sawn they are stored in the wood shed until they are needed. In the picture, my nephew Oliver Harris can be seen helping to stack the logs.

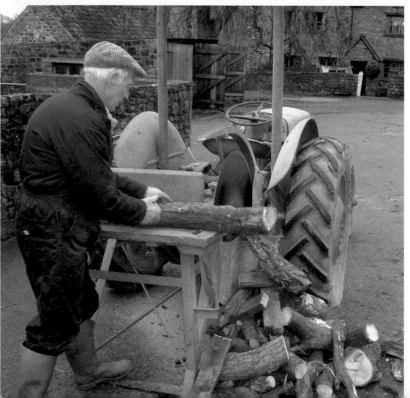

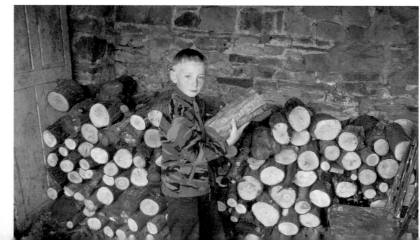

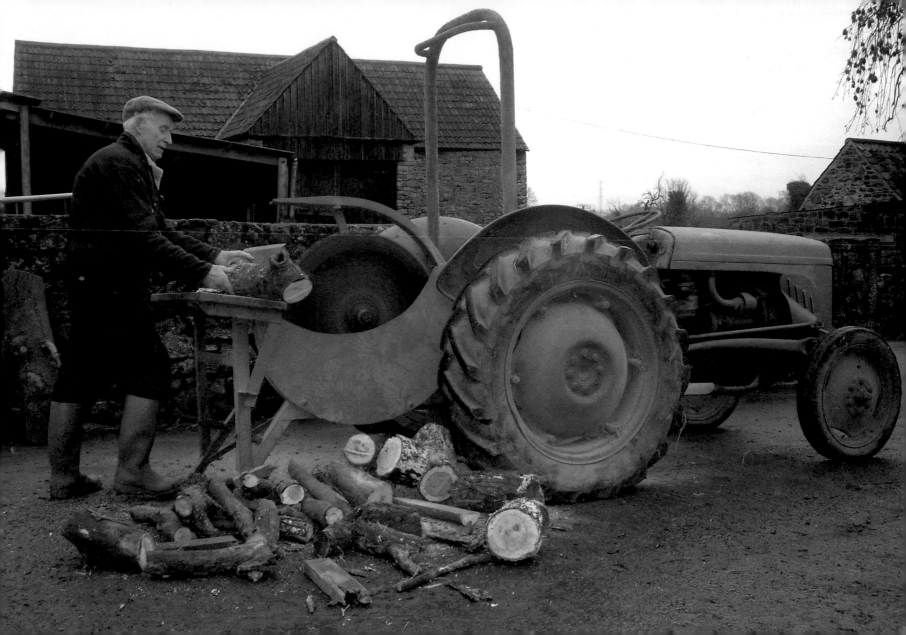

On cold December mornings it's quite common to wake up to a hoar frost. Hoar frosts occur when heat losses into the sky on cold, clear nights cause objects to be colder than the surrounding air, resulting in the formation of white ice crystals on an object's surface. A hard frost will create a ghostly scene with a dusting of ice forming on your feet as you walk through the fields and your breath showing up in front of you. On early mornings such as this, it can be difficult to get the tractor or milking machine to start so heaters are switched on in the parlour and an electronic engine heater is used on the tractor. High up in the sky, the vapour trails of aeroplanes show up more readily than normal – these are planes travelling to and from Heathrow across the Atlantic.

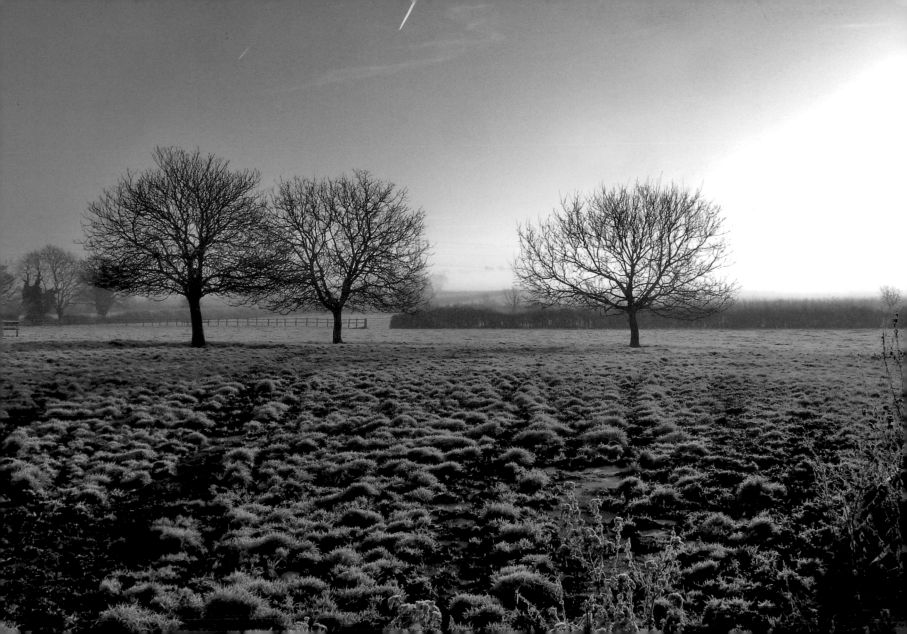

This main picture was taken early in the morning at sunrise looking west towards Bath. The red display is caused by the sun's rays being split into colours of the spectrum as they pass through the atmosphere, ricocheting off water vapour and particles. This view reminds me of the old saying 'Red sky in the morning, Shepherd's warning', which holds some truth when this scene is caused by an approaching storm cloud.

With Christmas approaching, the mistletoe growing on the old Morgan Sweet apple trees in the orchard provide a brilliant display of white berries. Mistletoe is a parasitic plant that grows on the branches of the tree and is spread by birds carrying the sticky berries it produces. Every year at Christmas we pick some mistletoe to hang in the farmhouse along with bunches of holly from a tree in one of the fields.

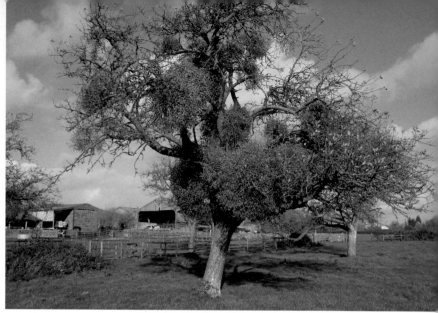

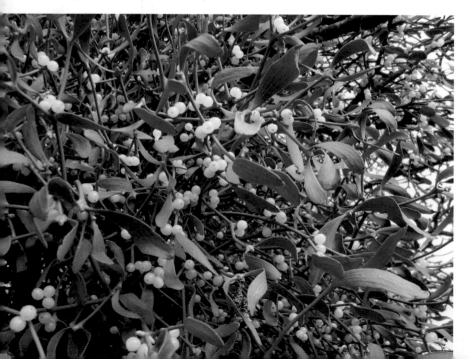

New House Farm does not stop for Christmas and over the holiday season my father, brother, and I work out a rota so that we all get some time off. On Christmas day the cows still have to be milked and Christmas dinner has to be fitted around this daily routine.

As the New Year approaches, it is time to reflect on the busy year that has passed and wonder what the forthcoming year will bring.

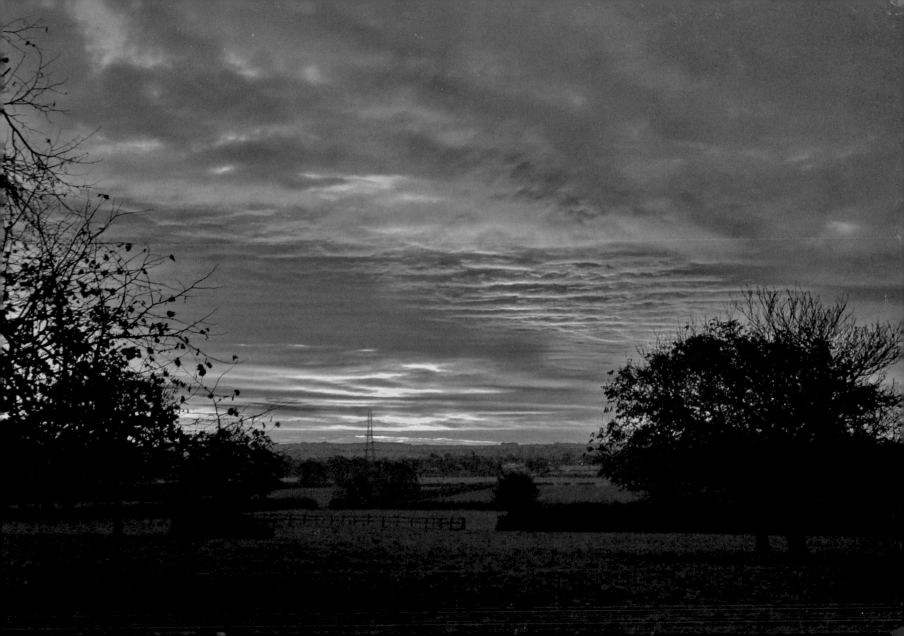

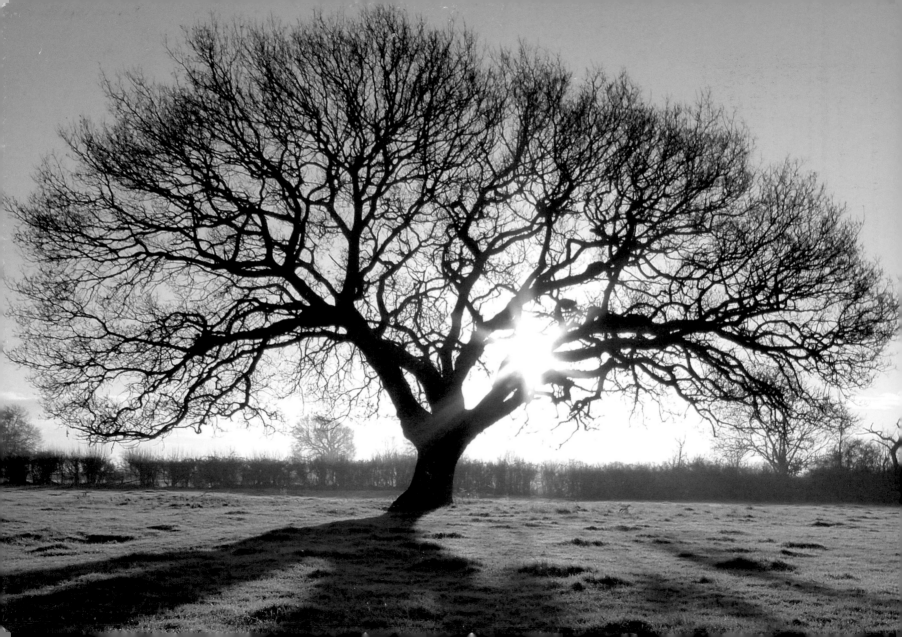